IMAGES
of America

# BREWING IN MILWAUKEE

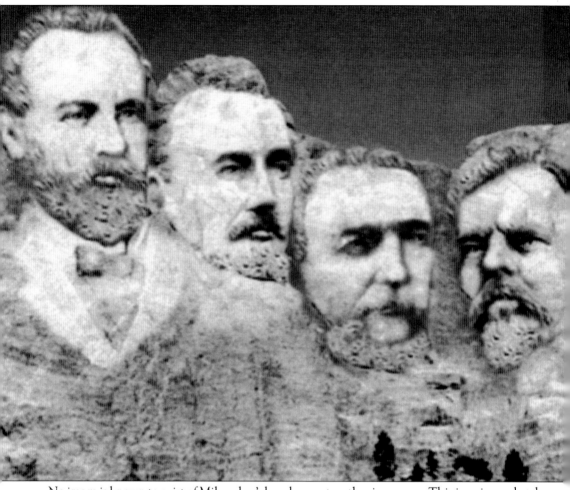

No image is known to exist of Milwaukee's beer barons together in a group. This imaginary sketch by Joel "the AleMonger" Mayer is his vision of how the four men who made Milwaukee famous should be recognized. From left to right are Joseph Schlitz, Frederick Miller, Valentin Blatz, and Capt. Frederick Pabst. (AleMonger craft beer blog, 2013.)

ON THE COVER: This photograph of a Miller Brewing Company bottling room, taken in 1899, illustrates the physical labor needed to run the brewery. Assigning workers task-specific jobs kept the plant running smoothly. This scene depicts an assembly line of sorts, with men in the background rolling full kegs of beer to be tapped and then transported to other workers who would fill the bottles with brew. (MillerCoors Milwaukee Archives.)

IMAGES
*of America*

# BREWING IN
# MILWAUKEE

Brenda Magee
Introduction by Frederick Gettelman

ARCADIA
PUBLISHING

Published by Arcadia Publishing
Charleston, South Carolina

Printed in the United States of America

Library of Congress Control Number: 2013938251

For all general information, please contact Arcadia Publishing:
Telephone 843-853-2070
Fax 843-853-0044
E-mail sales@arcadiapublishing.com
For customer service and orders:
Toll-Free 1-888-313-2665

Visit us on the Internet at www.arcadiapublishing.com

*For my husband, Gerard, my rock;*
*my children, Devon, Scott, Stacy, and Kimberly; and*
*my granddaughters, Mackenzie, Sophie, Regan, and Isabel.*
*Always remember—dreams don't have an expiration date.*

# CONTENTS

# ACKNOWLEDGMENTS

There are so many individuals and teams who have helped in the development of this book, but I first need to thank my in-house technical assistant, computer guru, and photographer, my daughter Devon; she has been a lifesaver on many occasions. Thank you to my husband, Gerard, for his patience, love, support, and confidence. Appreciation to Sarah Hopley and her team at the Milwaukee County Historical Society; Dave Herrewig, MillerCoors Milwaukee Archives; John Eastberg, Pabst Mansion museum senior historian; and Kevin Cullen, of The Discovery World Museum. My sincerest appreciation to Sid Hatch for sharing his extensive brewery knowledge and extraordinary bottle collection. Sincerest thanks to the Gettelman family for their support and confidence and for sharing their family history in photographs and stories, and last but not least, Michael Reilly of the Sussex-Lisbon Area Historical Society for his dedication in making the society's archives and other material current and available to the public. Many thanks to Mary Iannone for her assistance in manuscript review. I would also like to thank the collectors, historians, archivists, volunteers, and docents who preserve the past so that the stories can be told again and again. Thank you all.

For me, inspiration for this book came from a historic Milwaukee home, the Christopher Latham Sholes house (inventor of the first practical typewriter), where my employer, TRC Global Solutions, is based. If walls could talk, they would echo conversations that strategized and shaped both the city and county of Milwaukee. It is truly exciting to imagine the wheeling and dealing of an eclectic mix of Milwaukee businessmen that transpired in that home 150 years ago.

The images in this volume have been used with permission and appear courtesy of the following:
    AleMonger craft beer blog, 2013 (AM.)
    Author's private collection (APC.)
    Fred Gettelman collection (FGC.)
    Jim Haertel, Best Place at Historic Pabst Brewery (JH.)
    Jim Sponholz (JS.)
    Library of Congress Prints and Photographs Division (LOC)
    Mark Evers (ME.)
    Max Kade Institute collection, University of Wisconsin, Madison (MKI.)
    MillerCoors Milwaukee Archives (MCMA.)
    Milwaukee County Historical Society (MCHS.)
    *Milwaukee Journal Sentinel* (MJS.)
    Milwaukee Public Library (MPL.)
    Museum of Beer and Brewing (MBB.)
    Sid Hatch Bottle Collection (SHC.)
    State Archives of Florida (SAF.)
    The Biography Channel, www.biography.com (TBC.)
    Wisconsin Historical Society (WHS.)

# INTRODUCTION

The Milwaukee area went from a trading post to a settlement by 1820. In 1846, the settlements of Kilbourntown, Juneautown, and Walkerspoint joined to form what was to be Milwaukee. During this time, three Welshmen partnered to establish the first brewery, the Milwaukee Brewery, later called the Lake Brewery. Being Welshmen, they brewed what they knew, and that was an ale-style beer. Located on the dusty, dirty south side of town, the brewery did well enough until paying patrons got their first taste of real German lager. In the late 1840s and 1850s, a great number of German immigrants came to this country, many of them headed for Milwaukee.

Whether to escape hardship and political upheaval in one's homeland or to just start over, Milwaukee promised a bright future to anyone willing to "go for the gusto." Leaving family and friends was understandably a difficult decision but worth the risk. The advent of the steamship made crossing the Atlantic less of an ordeal and cut passage time in half. By the 1860s, there were more German-language speakers and German newspapers than English in Milwaukee. German influence has left its mark on the city, on its great food, restaurants, architecture, love of culture and heritage (every summer, German Fest welcomes thousands of Germans to the lakefront), and strong work ethic, as well as the love of good German-brewed beer. Milwaukee was at the start and heart of the beer industry for well over 100 years.

Familiar names today, such as Miller, Pabst, Schlitz, Blatz, Gettelman, and many others, have made up the local fabric of this industry. Milwaukee was attractive to German brewers because of its source of fresh water, ice for cellars, and barley and hops, all of which were essential for brewing a German lager-style beer. These early brewers were extraordinarily talented businessmen. They were aggressive industrialists who achieved success through hard work and sound business sense coupled with strong family ties. The brewing industry had a definite domino effect; new brewery concepts and innovations necessitated partnerships and assistance of local businesses for supplies and materials, thus fueling the growth of manufacturing in Milwaukee. In the early days, distribution was limited by how far a horse could travel in half a day. The real growth came with the railroad, allowing shipment to distance cities; this put Milwaukee on the map, and "Brewed in Milwaukee" became a sign of quality, answering the question of how and why Milwaukee became famous for its brewing.

It is amazing to think that three names all from one city would stand out nationally and internationally as world-leading brewers. Pabst and Schlitz traded the title of largest brewer for a while, and Miller was always just behind. With their need for equipment and services, these three companies were the engines of Milwaukee growth. These needs made many companies national companies in their own right. Milwaukee became a leader in manufacturing, printing, packaging, containers, and malting. The population and employment was staggering, with large number of immigrants coming to Milwaukee for jobs and a new life in America.

There were well in excess of 100 breweries in Milwaukee history, but with many name changes, closings, and poor sales, few remained after Prohibition. The golden age of the beer barons was

the 1890s through Prohibition. This period saw the growth in size of breweries and mansions; the creation of beer gardens, corner saloons, and tied houses; and the fastest-ever growth of the beer industry.

Today, Miller is the last surviving brewery from brewing's golden age; once a division of SABMiller, it merged with Coors as MillerCoors. Right here in Milwaukee, MillerCoors continues the great tradition of brewing quality products. Miller might be the biggest brewery in Milwaukee, but the city is seeing a rebirth of small-scale breweries, and quite a number of them are turning heads. The growth of microbreweries and brewpubs is bringing back that original innovative spirit to brewing in Milwaukee.

From the 1940s to the 1960s, virtually every household had some family connection to the brewing business in one form or another, be it brewing, packaging, distribution, or a secondary business supplying the breweries. This led to great brewery brand loyalty in taverns, restaurants, ballparks, and at home. For many years, Milwaukee was literally a closed market to outside brands. This changed with local strikes and increased radio and television advertising from national breweries. In Milwaukee today, it is still "Miller Time," and the phrase "PBR me" is heard in just about every local tavern.

Milwaukee and the beers that made it famous must have their story told and preserved. It is a heritage to be proud of. The brewing industry provided a great quality of life for its employees, including good wages and benefits, and encouraged a camaraderie not seen today. For the past 13 years, I have been involved with a group of dedicated people in the effort to form a Museum of Beer and Brewing located in Milwaukee to preserve this rich history, one my family was involved in for 107 years. My father was the last chairman of the A. Gettelman Brewing Co. until its sale to Miller Brewing Company in 1961. My mother's grandfather, Philip Altpeter, owned the Altpeter Brewery for a period, then converted it to a malting plant. Both sides of my family had their starts in this business, so I truly do have beer in my blood and honestly believe that this rich heritage should be preserved as a cornerstone of Milwaukee history. After all, virtually every visitor to Milwaukee asks about two things: breweries and motorcycles. I want us to be able to offer that historical perspective to our Milwaukee visitors. I hope that you will enjoy this effort and that it allows you to research and learn more about this great historic Milwaukee industry. This book attempts to visually capture the history and spirit of brewing in Milwaukee from the 1840s to today.

—Frederick Gettelman

# One

# MILWAUKEE'S EARLY HISTORY

Early inhabitants of Milwaukee, although not precisely known, were most likely offshoots of several East Coast native tribes forced westward as a result of encroachment by European settlers. The Iroquois, Chippewa, Sauk, Mascouten, and Potawatomi, to name a few, all passed through Wisconsin Territory. Those refugees choosing to stay behind banded together and became members of the Winnebago (Ho Chunk) and Menominee tribes. These Native Americans referred to this area as "the gathering place by the river." Its location between the Milwaukee River and Lake Michigan, which would later play a pivotal role in Milwaukee's growth, and the array of natural resources, made it an attractive location. Several navigable rivers, Lake Michigan's coastal waters, and abundant fertile land made Milwaukee a desirable site. Encouraged by rumors and stories of limitless fur-trading possibilities, other explorers followed the well-worn paths carved by these early people.

The French arrived next. Charged with the task of finding a water route to China by way of North America, Jean Nicolet made his way through the Great Lakes and is credited as the first European to enter Lake Michigan. He ventured as far as Green Bay and established Wisconsin's first fur-trading post. Although the Native American tribes had been forced westward due to encroachment, Europeans ventured west to seek their fortunes. French Canadians were the first white settlers to venture down Lake Michigan to establish a fur-trading post along the banks of the Menomonee River (which spills into Lake Michigan).

Jean Baptiste Mirandeau and Jacques Vieau established their trading post in 1795. These men dominated the fur trade for quite some time. Not until 1825, when Milwaukee's first mayor Solomon Juneau arrived and settled Juneautown, did things change. Not long after, Byron Kilbourn arrived and established Kilbourntown. A third visionary, George Walker, purchased land south of the river and established Walker's Point in 1835. It is from this point on that Milwaukee became a boomtown. The period from 1800 to 1849 was a time of steady growth, resulting in settlement by large waves of immigrants, particularly Germans.

The French Canadians were the first white men to explore Wisconsin. Under French control from 1671 to 1760, this region of North America became a fur trader's paradise. Lead by Louis Joliette and Fr. Jacques Marquette, an expedition set off in the spring of 1673 and established a trade route used until the 1860s, which nearly exterminated the beaver population. The expedition established a route that connected the Mississippi River to Lake Michigan. (TBC.)

Louis Joliet, born in Quebec, New France, had become a well-known cartographer by the age of 28, when Gov. Louis de Buade de Frontenac recruited him to survey all French territories. In May 1673, Joliet led a team of five, including Father Marquette, south through Wisconsin, where they followed a "great body" of water and discovered the Mississippi. Honored as the first white North American to achieve historical distinction, Joliet died in Canada in 1700. (TBC.)

Fr. Jacques Marquette, a French Jesuit missionary, founded Michigan's first European settlement, Sault Ste. Marie. Chosen along with Louis Joliet to lead an expedition to explore unsettled French territory, Marquette welcomed the opportunity to spread Christianity. Although his motive for escorting the team was religious, his diaries include entries of a geographic and scientific nature. Long forgotten, his journal remained unread in a Jesuit archive in Montreal for nearly 200 years. (TBC.)

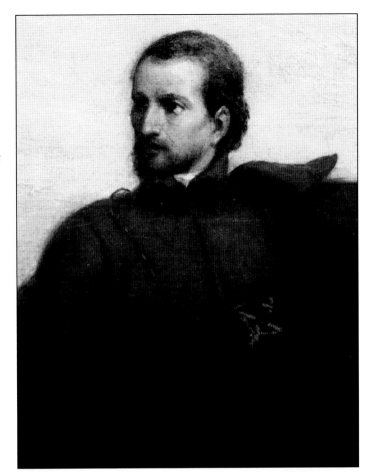

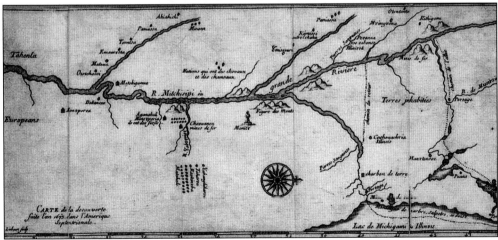

Known as the Map of French Discoveries in America in 1673, this map and Joliet's journals were recreated from his memory after original documentation was lost in a canoe accident. His recreated journal and map were published in 1681. The explorers spent five months observing and recording natural features, wildlife, and indigenous inhabitants encountered along the way. Although they paddled 2,500 miles, they fell short of the Gulf of Mexico by 435 miles. (APC.)

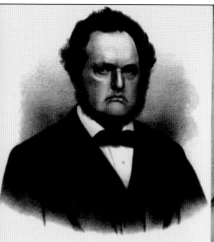

Milwaukee's founding fathers—from left to right, George Walker, Byron Kilbourn, and Solomon Juneau—were three men with three settlements and three distinct visions. Frequently each others' adversary, they eventually came to understand the benefits of a united city; laying their issues aside, they merged and incorporated into the City of Milwaukee on January 31, 1846, with Solomon Juneau as mayor. Besides mayor, Juneau served as Milwaukee's first postmaster and started the *Milwaukee Sentinel*, which would become the oldest operating business in Wisconsin. After two terms as mayor, Kilbourn turned his interest to railroads. Joining a handful of investors, they proposed the idea to run a rail line from Milwaukee to Waukesha, Wisconsin. Granted a charter in 1849, the committee established the Milwaukee & Mississippi Railroad Company, better known today as the Milwaukee Road. Walker, unlike the others, remained in public service. An influential business leader, he served two terms as mayor of Milwaukee and helped shape the city's first streetcar line. He later became a member of the lower house of the territorial legislature and a state assemblyman. (MCHS.)

# Two

# German Immigration

Unlike Germans a decade earlier, politics was a reason for immigrants to flee their homeland during the 1840s. Forced land seizures, unemployment as a result of industrialization, increased competition from British goods, and repercussions from the failed German Revolution of 1848 were all solid reasons to find a better life elsewhere. Because of industrialization, cross-Atlantic passage was faster, safer, and less expensive, making the decision to immigrate easier. For as many reasons immigrants had to leave their homeland, America had as many to welcome them. Wisconsin, like other states, encouraged settlement and enacted legislation to market itself. As a result, the state published informational pamphlets similar to today's vacation brochures that included weather conditions, employment, business opportunities, available land, natural resources, and information critical to immigrant assimilation. Thousands of pamphlets were printed in several languages and distributed in East Coast cities as well as European countries. The wait was on.

And come they did, by the thousands. Early immigrants of the 1840s included the French, Italian, Greek, British, and some Germans. Not until the second wave of the late 1850s were most immigrants German. Many newcomers arrived with the necessary skills and occupations; for others, the only skill needed was their brute strength. Opportunities were endless. Eager for new beginnings, Germans arrived with little more than high hopes; more important, they brought their work ethic, culture, and thirst for beer. For Germans, beer was, and still is, not only a beverage to quench thirst but a larger social aspect of German life. With the growth in population, the need for additional microbreweries evolved, usually one-man operations brewing and selling from their home. It is this second wave of German immigrants that prompted new brewery startups. By 1860, two hundred breweries operated in Wisconsin, with over 40 in Milwaukee alone. Of the Milwaukee breweries, names such as Best, Pabst, Blatz, Schlitz, and Miller—all German—can still be found on bottle labels today. Acquisitions, buyouts, name changes, and mergers have all affected the public's perception of Milwaukee's beer barons, their beer, and the city that brewed them.

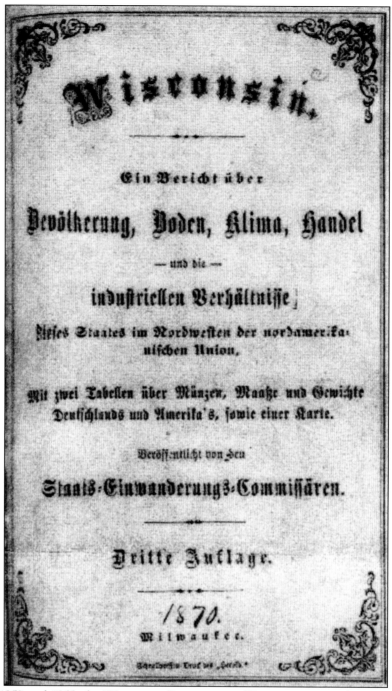

Between 1852 and 1855, the Wisconsin Commission of Emigration actively encouraged the settlement of European immigrants in Wisconsin. To do so, pamphlets, printed in several languages, were released throughout the East Coast as well as all European countries. This German pamphlet welcomes immigrants and includes information on state climate, businesses, land acquisition, trade, industrial conditions, and population. Also included are tables on weights, measurements, and German monetary conversion rates. (MCHS.)

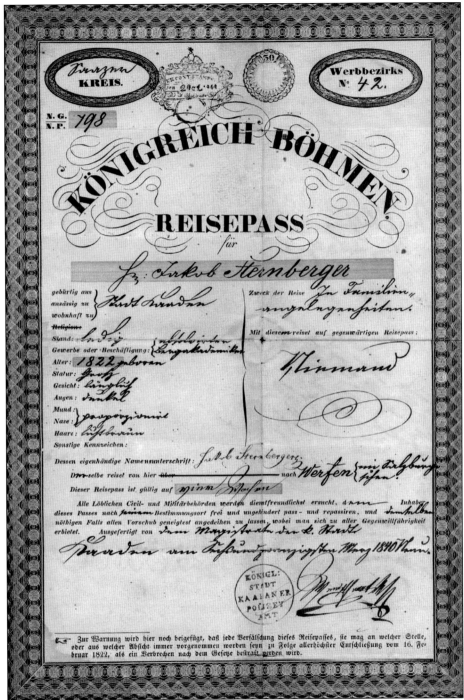

Travel documents today, although quite involved and just as important, are nowhere near as elaborate as this example. But travel 170 years ago was a very special event. This is a page from Jacob Sternberger's German passport in 1840. It states that he is single with light brown hair and dark eyes and is about 20 years old. Family business, the reason for the travel, would take him about four weeks. (MKI.)

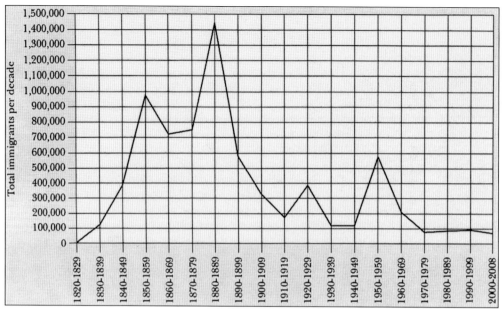

Milwaukee's population growth undeniably was spurred by the opportunities Wisconsin offered. Wisconsin promised a better life, no matter one's skill, financial status, gender, or ethnic group. Immigrants by the thousands, especially Germans, flocked to Wisconsin, particularly Milwaukee, to grab their share of the American dream. The graph above displays immigration statistics for the United States from 1820 to 2008. (MCHS.)

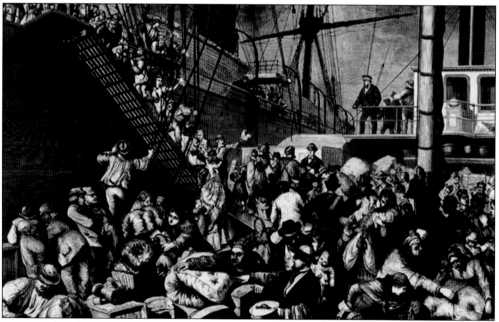

Reasons other than politics encouraged Germans to flee their homeland by the thousands. Stories of prosperity and opportunity convinced millions that a better life waited across the Atlantic Ocean. Thanks to the industrial revolution, the change from sail to steam made crossing the Atlantic safer, faster, and less expensive, encouraging immigration even further. The 1830s brought the first wave of German immigrants, and by 1859, over one third of Milwaukee was German. (MCHS.)

16

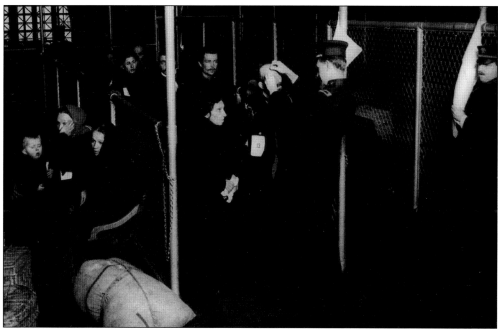

Ellis Island, located in Upper New York Bay, processed millions of new immigrants entering the United States between 1892 and 1954. Considered the gateway to America, records indicate that 40 percent of current residents can trace at least one ancestor to Ellis Island. The physical exam, the first of several, was a quick once-over to catch obvious ailments. Suspicious findings and physical deficiencies earned an immigrant a chalked "X" on their clothing, forcing them to await further examination. (LOC.)

Milwaukee's rich German heritage drew thousands of visitors to Milwaukee to enjoy beer gardens, brewery tours, and good old-fashioned *Gemütlichkeit*. During the late 1800s and early 1900s, Milwaukee became a popular convention city. This image from the June 16, 1928, edition of the German newspaper the *Milwaukee Herald* documents a group of Germans in town for the annual Sangerfest, a German musical extravaganza that features singing societies from around the country. (APC.)

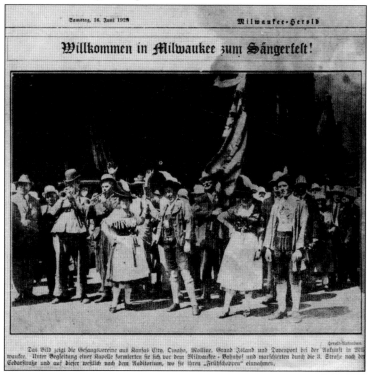

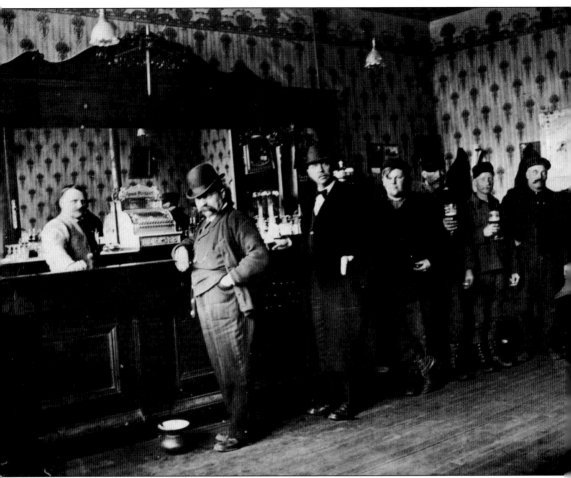

Although most German immigrants arrived with little more than they could carry, they brought with them their strong traditional customs for comfort to Milwaukee. Beer, both the process and the consumption, was, and still is, a social event. Gathering with friends and neighbors in a local tavern was a custom continued in Milwaukee. This photograph captures what appear to be three distinct classes of patrons, all enjoying their favorite beverage. (MCHS.)

# *Three*

# EARLY BREWERIES

Frequently, beer and breweries are acquainted with Germans, but in Milwaukee's early history, this was not necessarily the case. In the 1830s and 1840s, early immigrants arriving in Milwaukee included more Irish and English than Germans. Early British settlers socialized on whiskey, rum, and ale in small neighborhood saloons. One such entrepreneur, Richard Owens, found his way to Milwaukee in 1840. Eager for an opportunity, Owens partnered with fellow Welshmen William Pawlett and John Davis to establish the Milwaukee Brewery. Situated on the city's south side, their enterprise consisted of a small wooden structure housing a makeshift brew kettle made from a copper-lined wooden box capable of producing just five barrels at a time. With the production of both whiskey and ale (a top fermented brew), ale became the preferred choice, especially since whiskey was taxed and ale was not. The year 1845 marked a pivotal point for Owens: he bought out his partners and became sole proprietor of the newly named Lake Brewery.

A year after Owens opened his doors, Hermann Reuthlisberger launched the city's second brewery. Good at first, the business slowly declined and was sold to John Meyer, a baker. A better baker than brewer, Meyer sold out to his father-in-law, Francis Neukirch, in 1844, who then partnered with son-in-law Charles T. Melms, opening the Menomonee Brewery. During the 1850s, Milwaukee's German population exploded, resulting in competition of all sorts, especially beer. New startups began selling lager—the true drink of Germans. Small microbreweries found their niche and loyal patrons. Names such as Borchard, Gettelman, Jung, Falk, and Graf started small but eventually grew beyond their dreams. Not only were these earlier, smaller breweries important to Milwaukee's economy, they became the foundation of the large modern brewery complexes. Given the number of breweries, though some were short-lived, they all definitely influenced many supporting industries.

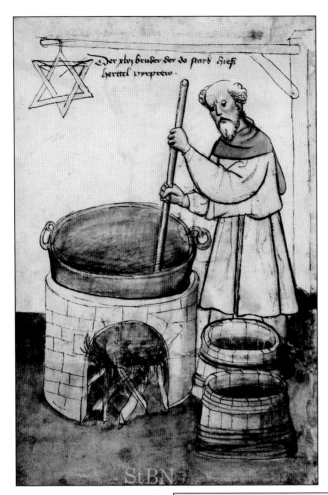

Believing great beer should include the finest ingredients, the Bavarian Reinheitsgebot (or the Bavarian Purity Law) became law in 1516, permitting only three ingredients in beer: water, barley, and hops. First produced by monks to guarantee purity, individual breweries soon followed. To advertise their compliance and the purist product, brewers hung a six-pointed brewers' star above their establishment. The image at left depicts a monk with the posted brewer's star. (MCHS.)

Pictured are the five components of a brewer's star in relation to brewing and alchemy. Combined, these signs suggest harmony, peace, and balance—all necessary in the brewing process. The six-pointed brewers' star, a sign of purity and harmony, is the oldest guild emblem for brewers. Many breweries still incorporate the star into their logos and signage to this day. (MBB.)

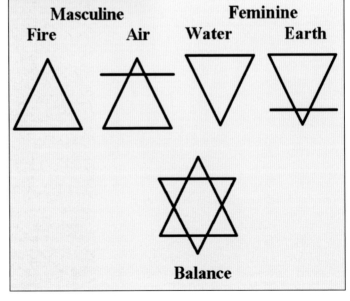

Philllip Altpeter began his brewery career as a cooper in 1848, and in 1856, he established the Northwestern Brewery, producing Weissbier only marketed in Milwaukee. Profitable at first, sales eventually lagged enough to warrant shutting down the brewery in 1884, when focus shifted from production to malting. This new enterprise required new, stronger quarters, resulting in a state-of-the-art brick plant that produced malt until 1902. (MCHS.)

From clay bottles to glass, breweries have always turned to technology for efficiency and a larger profit margin. This half-pint bottle from the Altpeter Brewery is molded from amber glass and is center embossed. As it was easier to ship, glass was the wave of the future. (SHC.)

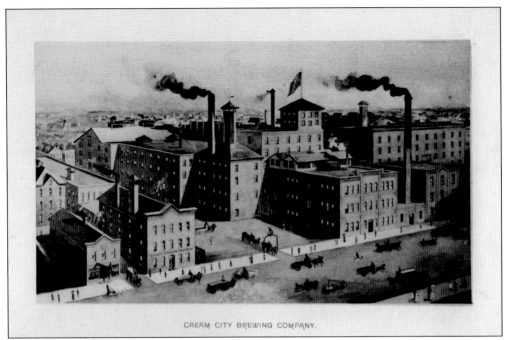

CREAM CITY BREWING COMPANY.

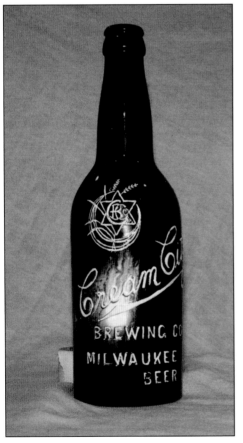

Located at the northeast corner of Thirteenth and Cherry Streets, the brewery began with the partnership between brothers George and Conrad Wehr and Christopher Forester in 1853. Seasonal at first, they only brewed during winter months, storing kegs in the basement. In 1877, it became the Cream City Brewery under partners William Gerlach and Jacob Veidt. The brewery continued to change hands until 1937, when burdening debt forced a closure. (MCHS.)

The Cream City Brewery was established by William Gerlach (a maltster), Jacob Veidt, and Christopher Forester, who improved the brewery enough to produce over 25,000 barrels of beer early in the 1880s. Ownership varied, and the business even survived Prohibition as the Cream City Products Company. This amber pint bottle has an applied crown and was bottled by William Franzen & Son (WF&S) of Milwaukee. (SHC.)

Franz Falk became a master cooper as his father's apprentice in Miltenberg, Germany, after which he apprenticed at the Miltenberg brewery to become more diverse in the brewery industry. In 1848, Falk immigrated to Milwaukee where he found employment in both August Krug's and C.T. Melms's breweries. Seeing an opportunity, Falk partnered with Frederick Goes and established a malting and brewing enterprise known as the Bavaria Brewery. (MCHS.)

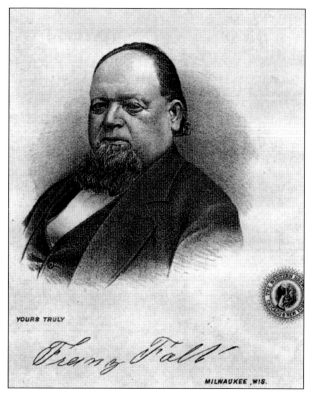

YOURS TRULY

MILWAUKEE ,WIS.

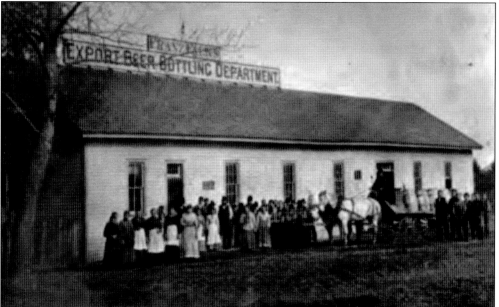

The partnership of Goes and Falk created the Bavaria Brewery in 1855 and lasted until 1866 when Falk bought out his partner, allowing Goes to assume full control over his malting business. In 1872, Falk closed this brewery and relocated in a larger, more modern plant in the Menomonee Valley, which included an on-site malting house. The Menomonee Valley site would eventually be instrumental in the development of Falk Industries. (MCHS.)

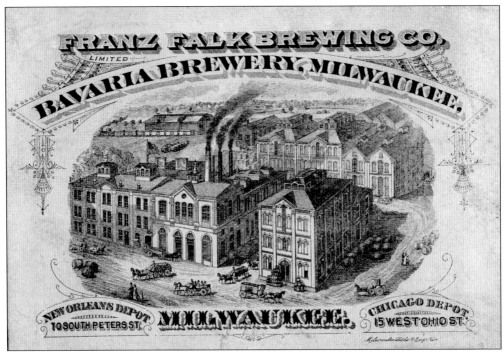

The new Bavaria Brewery, a model of efficiency, offered the latest technology of the era, but its greatest strength was its location adjacent to the rail yards. Direct access by the Chicago, Milwaukee & St. Paul line made national distribution possible. Addressing the needs of a national market validated Falk's business strategy. Falk's Export Beer had become an award-winning premium beer in 1880. (MCHS.)

When Franz Falk joined the family brewery along with his brother Louis, the brewery incorporated as the Franz Falk Brewing Company in 1881. Franz Falk Sr. became president; Louis, vice president; and Franz Jr., secretary. Through hard work, the Falk management team helped the Bavaria Brewery become the fourth largest brewery in Milwaukee. With the death of Franz Sr. in 1882, Franz Jr. and Louis assumed leadership of the company. (MCHS.)

After the death of their father, Louis assumed the president's chair and, with Franz's assistance, invested heavily in the plant, making improvements. The brothers were then joined by younger brothers Otto and Herman. Otto came on as general manager, and Herman (who would later lend the "Falk" name to a different enterprise) as mechanical supervisor. This new management team opened new product markets in regions such as Mexico, South America, and the East Indies. (MCHS.)

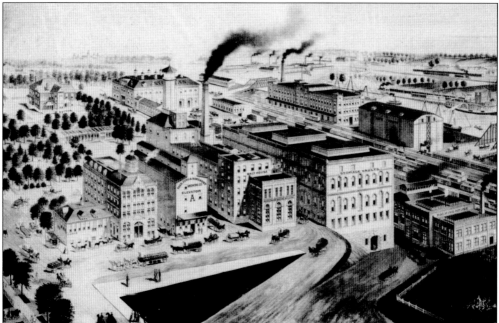

The year 1888 brought a merger with the Jung and Borchert Brewery, which formed the Falk, Jung & Borchert Brewery Corporation. At first the merger seemed to be a good fit, but bad luck soon fell on the brewery. Fire, a frequent menace in breweries, caused complete destruction in 1889, but the company rebuilt. A second fire in 1892 was worse. In a valiant attempt to meet customer demand, Falk purchased raw product from Pabst to finish off and sell under their label. (MCHS.)

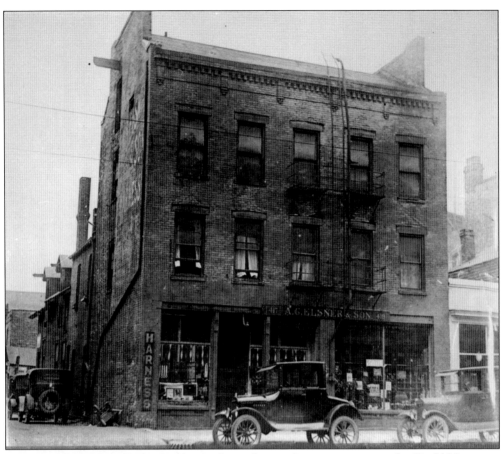

Lesser known but important was the Gipfel Union Brewery, located at 423–427 Juneau Avenue. The three-story, gable-roof, Federal-style brick structure was built in the 1840s by Charles Gipfel. The brewery produced a Weissbier, or white beer, until the early 1890s. The building housed many businesses, including a harness factory, the Marmon soap factory, a barbershop, and shoe repair. The second and third floors served as a boardinghouse. (MCHS.)

The Gipfel brewery, located at approximately N. Fourth St. and Juneau Avenue, used ceramic bottles such as these for their Weissbier. Non-alcoholic beverages, as well as beer, were commonly kept in stoneware bottles during the 19th and early 20th centuries. Stoneware provided the ultimate protection against damage from light. Eventually, stone bottles were replaced by glass bottles, which were easier to cap. Today, these bottles are very rare and extremely collectable. (SHC.)

As with most old buildings, the Gipfel Union Brewery gained a varied and sordid history over time, but it was neglect that would do it in. In 1985, a group supported application for historic preservation protection, citing the building's architectural significance and its historical term as an independent brewery. Long regarded as one of Milwaukee's most historically important commercial buildings, it eventually became an eyesore and was eventually razed in 2009. (MCHS.)

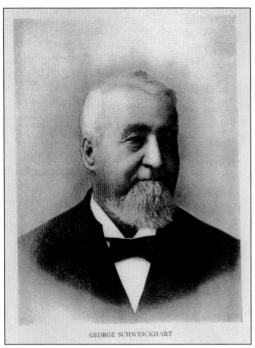

GEORGE SCHWEICKHART

Born in New York, George Schweickhart apprenticed in the family brewery. Seeking his own path, Schweickhart headed to Milwaukee to become a farmer in 1854. Stumbling on the perfect parcel, he soon learned the tract had the foundation of an abandoned brewery. Price and fate convinced George to rethink his future. In 1856, George opened the Menominee Brewery. (FGC.)

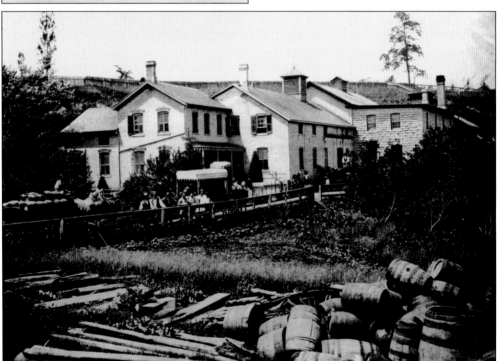

From the ashes of an abandoned brewery site, George Schweickhart established the Schweickhart Brewery, also known as the Menominee Brewery. This image illustrates the original farmhouse (left) adjacent to the brewery. To the far right is the malt house. Loaded wagons file past the farmhouse ready to make deliveries. Very little went to waste at the brewery; used and damaged barrels (foreground) were recycled for later use. (FGC.)

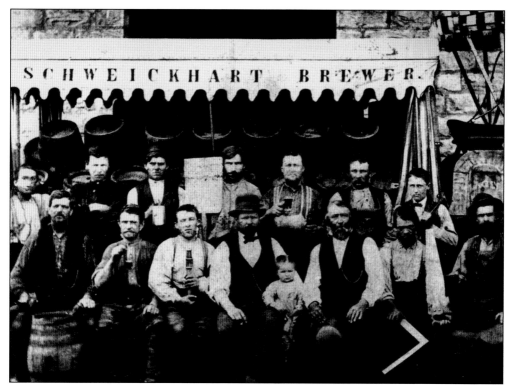

No matter the job description, every man was critical to the brewery's success. The coopers from the Schweickhart Brewery pose with tools in hand before a full wagonload of beer, ready for delivery. The wagon had the capacity to carry 35 half-barrel loads. Transporting beer was not an easy feat in winter months, when the wagon had to be relayed up icy snow-covered hills to deliver in Milwaukee. (FGC.)

Adam Gettelman, born in Germantown, Wisconsin, in 1847, left the family farm for Milwaukee to study at the John Ennis Brewing School, after which he apprenticed at the Schweickhart Brewery. He quickly advanced into management. As sometimes happens, Gettelman married the boss's daughter Magdalena in 1870 and gained a share in the business. In 1876, the brewery changed ownership and became the A. Gettelman Brewing Company. (FGC.)

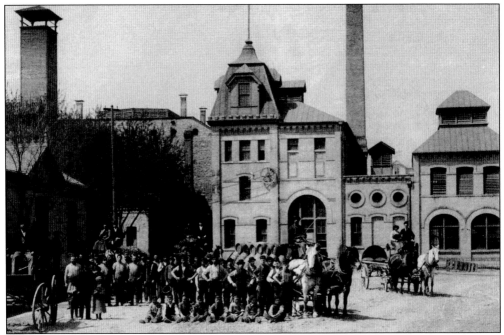

From front office clerks to delivery wagon teamsters, all the A. Gettelman Brewing Company employees proudly pose for a company picture. Taken in the 1880s, this photograph shows the brewery after considerable expansion. Built during the Victorian era, plant buildings reflect the architecture of the time. Buildings to the left are the original Schweickhart Brewery buildings. (FGC.)

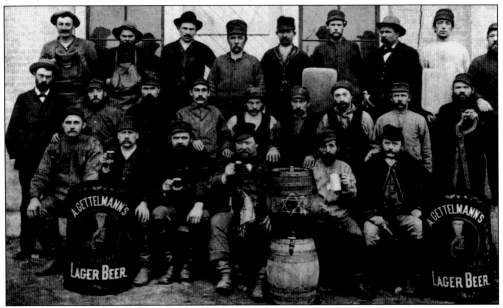

Enjoying the fruits of their labor, with full mugs in hand, a group of employees pose for this photograph in the brewery yard. Notice the six-pointed brewers' star chalked on the barrel. The star, a sign of quality and purity all brewers were proud to display, was frequently incorporated in a brewery logo. (FGC.)

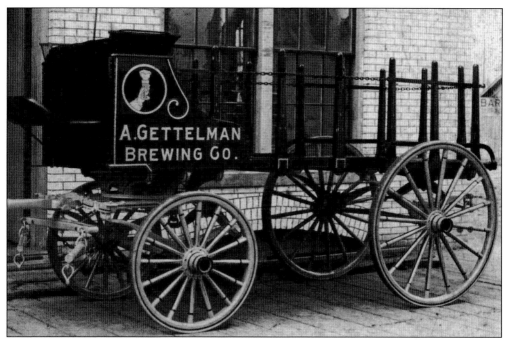

Pictured here is an early A. Gettelman Brewing Company delivery wagon designed to haul barrels of beer to commercial customers at neighborhood taverns. Wagons loaded to the top would weigh hundreds of pounds, requiring a team of draft horses specifically bred to handle heavy loads. (FGC.)

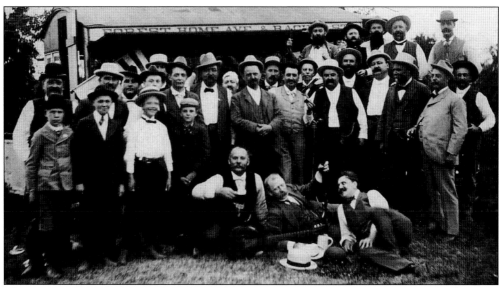

This group of men and boys, friends and brewery rivals, gather for a little rest and relaxation. Photographed in 1895 on Albert Blatz's farm, the men enjoyed a day of shooting, good food, good beer, and each other's company. (FGC.)

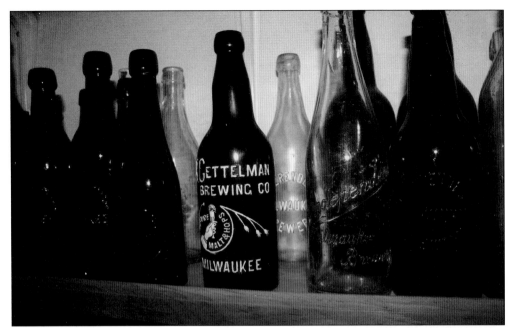

This photograph includes an A. Gettelman Brewing Company amber bottle. This pint bottle was produced by William Franz & Son of Milwaukee sometime between 1895 and 1926. (SHC.)

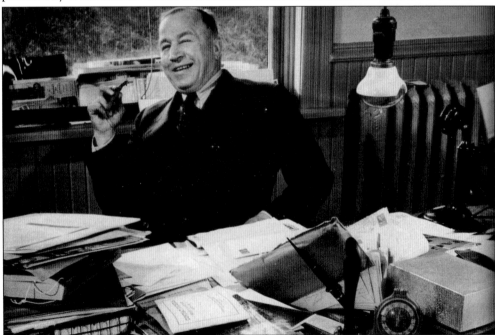

Adam and Magdalena Gettelman had six children, but it was Frederick "Fritz" Gettelman, their youngest child, who brought the most innovation to the brewery. Fritz became president of A. Gettelman Brewing Company in 1929. Beer was his work, but his passion leaned toward mechanical engineering; Fritz had a knack for solving problems. His innovations and inventions included an improved beer barrel, commercial grade snowplow, and consultation with the American and Continental Can Company to develop aluminum beer cans. (FGC.)

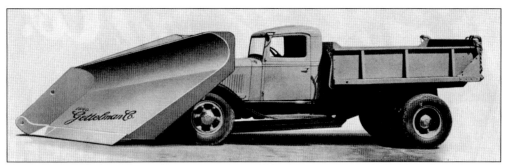

Surviving Prohibition required new strategies, and like its competitors, the A. Gettelman Brewing Company produced its own brand of near beer and sodas, as well as high-speed snowplows. The snowy roads of Wisconsin inspired Fritz's idea. Sold under the Fred Gettelman Company, the business produced two snowplow models, blade and V type, designed to fit Chevrolet trucks. State, county, and city street departments found a reliable and efficient answer to Wisconsin winters. (FGC.)

This photograph depicts members of the Five O'Clock Club celebrating in the caves of the original Schweickhart Brewery. The caves were converted to a rathskeller (a tavern below street level) to accommodate the club's opening. The club, comprised of several Milwaukee businessmen as well as Gettelman Brewery employees, met at 5:00 every Friday to enjoy a good meal and friendship. Fritz Gettelman is on the right. (FGC.)

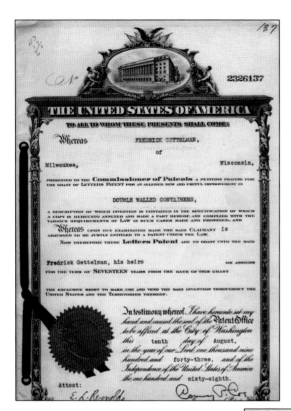

This is a copy of the letters patent granted to Frederick Gettelman on August 10, 1934, for double walled containers. The registered patent number, appearing in the upper right, is 2326137. Just one of Fritz Gettelman's innovations, it was able to change both the storage, flavor, and freshness of beer. This technology has been adapted for other uses such as food, cosmetic, and scientific applications. (FGC.)

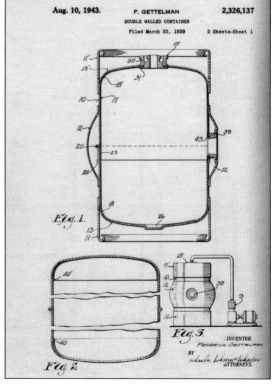

Conceived on a scrap of brown butcher paper, Fritz sketched a diagram of his improved steel barrel. Sketch in hand, he approached several business acquaintances and proposed his idea. Although he met with several rejections, Fritz never gave up; finally, A.O. Smith agreed to take the contract. (FGC.)

The Five O'Clock Club members pursued other activities such as hunting and fishing, which developed into several instructional manuals intended as giveaways. The A. Gettelman Brewing Company printed several versions, including this one on fishing and camping. Extremely popular, the booklets offered practical lessons on how to tie a fly, foil pesky mosquitoes, filet a fish, build a campfire and "make your own waterproof matches, by dipping match ends in melted paraffin." (FGC.)

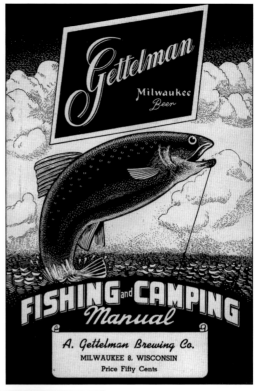

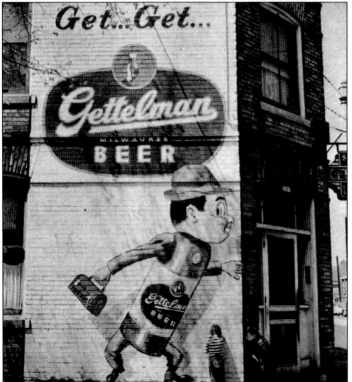

Milwaukee breweries were very competitive in their outdoor ad placement, and a lack of wall space necessitated clever and visible advertising. Fritzie, Gettelman's trademark, was everywhere. Conceived by artist Elton Grafft, this 1952 ad campaign adapted Fritzie in humorous spots. From tightrope walking across telephone wires to peeking around corners, Grafft's creative talents made Fritzie a household name. (FGC.)

Fritz wasn't the only Gettelman with a passion for problem solving, Tom, Fritz's son, joined the family business after graduating from the Siebel's Institute of Technology. Shortly after, he devised this six-pack carrier. The cardboard carrier slipped over the bottle caps, while the slotted pieces caught the crown of the cone-top cans from underneath, holding the dangling cans. Known as the "Pik-Up-Six," this improvement dramatically cut costs. (FGC.)

After nearly 105 years, the Gettelman and Miller breweries stood as neighbors through the course of history—some good and some bad. Although competitors, their bond of friendship was deep. When Miller changed hands and sought to service the local Milwaukee market, the company naturally turned to Gettelman to fill that niche. On January 14, 1961, through a mutual agreement, Miller Brewing Company acquired the A. Gettelman Brewing Company. (FGC.)

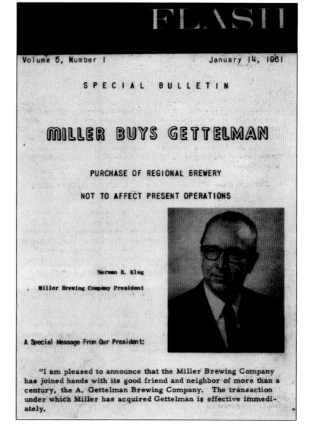

Charles Theodore Melms immigrated from Ruegen, Germany, to Milwaukee in 1843. After marrying Marie Neukerk, the daughter of Francis Neukerk, owner of the Menomonee Brewery, Melms became a partner in the brewery. An avid sportsman, philanthropist, and adept entrepreneur, Melms's brewery eventually became the largest in Milwaukee. (MCHS.)

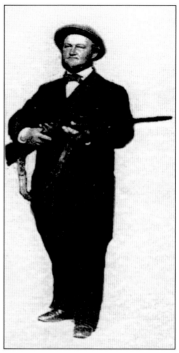

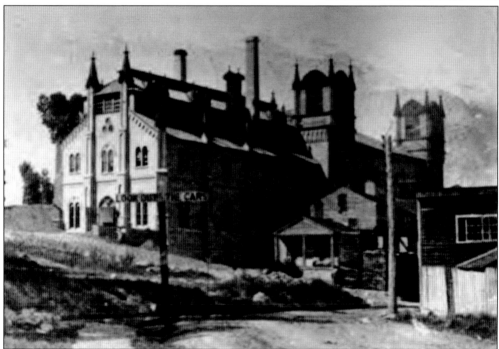

Melms, considered the first beer baron of his time, assumed the Menomonee Brewery from his father-in-law in 1859. Immediate production changes resulted in higher sales and better profits. Assuming a lavish lifestyle that complemented his newfound wealth no doubt earned Melms that title; all aspects of his life reflected his position. Living the style of the rich and famous, Melms expanded his brewery and built an extravagant mansion next door. (MCHS.)

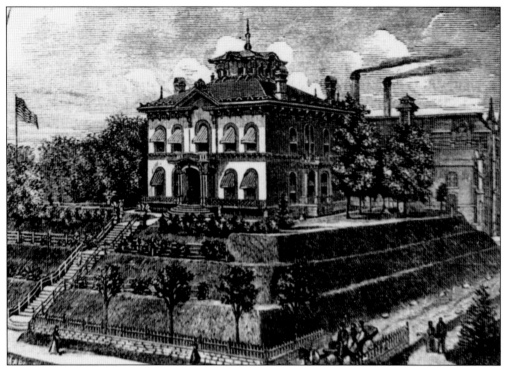

Melms enjoyed the fruits of his labor and a lavish lifestyle. He spared no expense on his enormous Italianate-style mansion overlooking the valley. Unfortunately, he did not live long to enjoy it. At the age of 50, he died from an infection, leaving a widow and seven children. Pabst eventually purchased the property and operated it as the South Side Brewery, located on Virginia Street. (MCHS.)

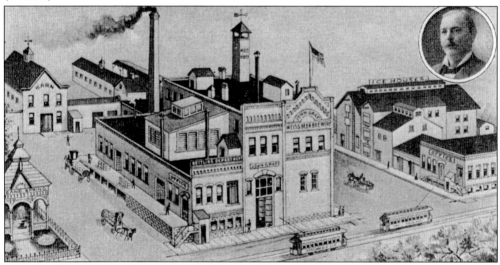

Established in 1874 by John Graf and Phillip Madlener, the South Side Brewery and soda water factory produced Weissbier, as well as soda water, until Prohibition. One step up on his competitors, Graf continued bottling soda to survive. Eventually, a name change to Graf Beverages supported only one product: soda. Best known for its root beer, it bears John "Grampa" Graf's image. Still produced under the Graf label, it is owned by Canfield Company. (MCHS.)

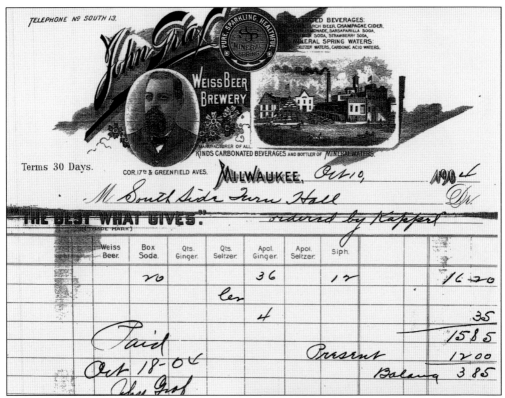

| | Weiss Beer. | Box Soda. | Qts. Ginger. | Qts. Seltzer. | Apol. Ginger. | Apol. Seltzer. | Siph. | | | |
|---|---|---|---|---|---|---|---|---|---|---|
| | | 20 | | | 36 | | 12 | | | 16 20 |
| | | | | les | | | | | | |
| | | | | | 4 | | | | | 35 |
| | Paid | | | | | | | | | 15 85 |
| | Oct 18-04 | | | | | Present | | | | 12 00 |
| | John Graf | | | | | Balance | | | | 3 85 |

This invoice, dated October 10, 1904, was for soda delivered to Turner Hall. It appears that John Graf delivered the order, as his signature is attached. At the top of the invoice is an image of "Grampa" Graf. (MCHS.)

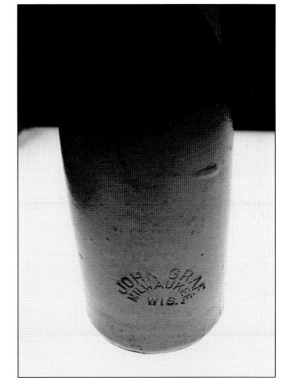

This John Graf clay bottle would have been used to bottle the brewery's Weissbier, as well as its soda water. Clay vessels were sturdy enough to be reused several times over. (SHC.)

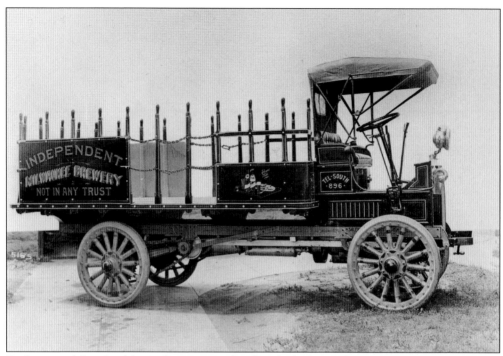

By the second decade of the 20th century, technology had advanced enough that even the smallest factory or plant could afford a gasoline-powered vehicle. This photograph of an Independent Milwaukee Brewery delivery truck is dated around 1915. The truck's side confirms that it is not affiliated with any other brewery ("Not in Any Trust"), and advertises its probable slogan, "The Real Life." (MCHS.)

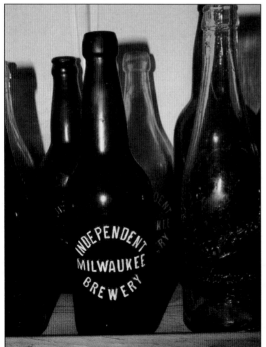

The Independent Milwaukee Brewery, established on Milwaukee's south side in 1901 by Henry Bills and Emil Czarnecki, produced several brands, but its Braumeister lager became a household name. Prohibition took its toll on all breweries, but when it ended, Bills and Czarnecki were ready. The Independent was Wisconsin's first brewery to resume production. In 1962, G. Heileman purchased the brewery. This center-embossed amber pint was manufactured by WF&S. (SHC.)

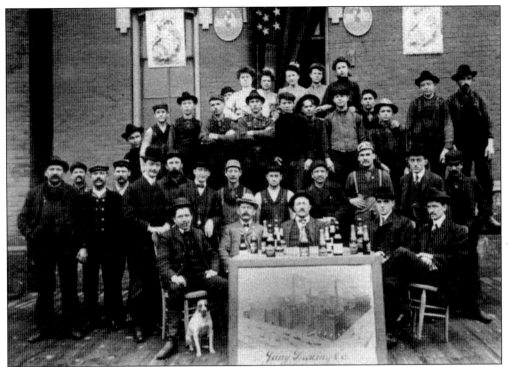
Built on the site of the Oberman Brewery, Phillip Jung established the Jung Brewing Company in 1896. After several attempts at partnerships with other brewers, his last venture, partnering with Falk, Jung & Borchert Brewing Company, gave him reason to become his own boss. The gathering of brewery employees, including a dog, seems to capture everyone in a proud moment. (MCHS.)

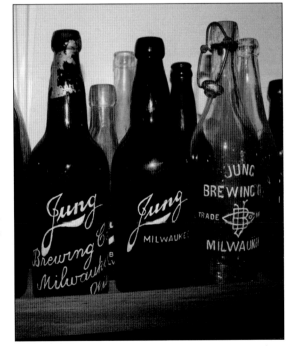
This rare trio of Jung Brewing Company bottles is a collector's dream. The amber pint at left is marked "SB&G" and has a bit of foil molded to the neck, adding interest to its story. At center is another amber pint, with no maker stamp. At right is an aqua bottle with a lighting stopper that reads, "this bottle never sold," showing no noted maker. (SHC.)

41

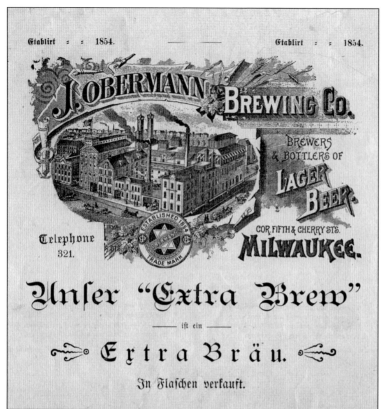

Cobbler, shopkeeper, and brewer Jacob Oberman was quite the entrepreneur, but he was most successful as a brewer. From a two-story frame building to a brick brewery and icehouse, his business occupied the corner of Fifth and Cherry Streets for 42 years. In 1877, the brewery produced 7,000 barrels a year, necessitating the addition of a bottling plant the same year. In 1896, the brewery was sold to Phillip Jung. (FGC.)

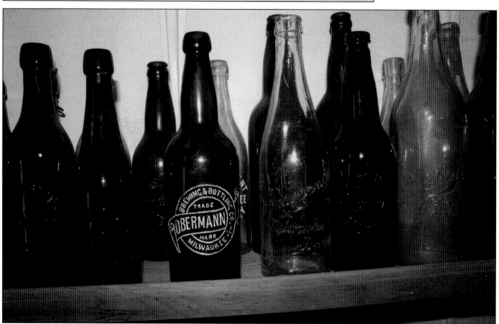

The Oberman Brewing Company was located on the northwest corner of Cherry and Fifth Streets. Jacob Oberman and his son George operated the Oberman brewery together from 1854 to 1896. This amber pint was bottled by WF&S. (SHC.)

# Four

# MILWAUKEE'S
# BEER BARONS

Encouraged by their father, Jacob Best Sr., to explore economic opportunities in America, the four Best brothers immigrated to Milwaukee. The first family enterprise started out as a vinegar factory, established by the partnership of Charles, Jacob Jr., Lorenz, and Philip Best in 1840. The distillery did well, but the brothers soon realized another opportunity. Letters home carried stories of countless opportunities available in the growing city of Milwaukee, especially in the brewery industry. Encouraged by their success and potential opportunities, Jacob Sr. sold his German brewery and joined his sons. He had every intention of making his mark on the city of Milwaukee, the growing German population, and their desire for real German lager.

Shortly after Jacob Sr.'s arrival, father and sons teamed to establish the Empire Brewery in 1844. Originally, the enterprise consisted of a vinegar factory, whiskey distillery, and brewery. Realizing more profit was possible in the production of beer, the distillery and vinegar factory were shut down. The new brewery might have been in Milwaukee, using Wisconsin ingredients, but Jacob Sr. brewed as though he was still in Mettenheim, Germany. He took pride in continuing his tradition of using only pure, fresh water and quality ingredients. The first year of production yielded 300 barrels of light lager. In 1850, Charles and Lorenz left the company and established the Plank Road Brewery down the road. As Milwaukee grew, so did Best Sr.'s brewery, but with growth and expansion (opening the New York market) came changes. In 1853, Jacob Sr. retired. Phillip and Jacob Jr. continued operations under the name of Philip Best Brewing Company with Phillip as president and Jacob Jr. as vice president. Jacob's daughters Lisette and Maria also helped with the business; they married the right men. The company continued under this name until Fred Pabst assumed control and changed the name to Pabst Brewing Company.

Jacob Sr. was an expert businessman, astute and industrious. He believed, as described in his 1861 obituary in the *Journal Sentinel*, "Your word is your bond." Living by this, Best laid the foundation for an amazing company that would surpass all other breweries of the time.

Jacob Best Sr.'s sole purpose for immigrating to Milwaukee was to brew beer. Arriving experienced in business and brewing, it took little time to get the Empire Brewery off the ground in 1844. This small, family distillery was located near Ninth and Chestnut Streets and originally produced spirits and beer. Eventually, realizing the potential profit in beer alone, Jacob Sr. and his sons concentrated on the production of a light lager. (MCHS.)

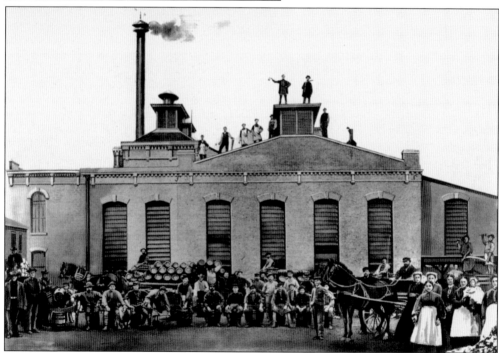

This is the original Empire Brewery established by Jacob Best Sr. and sons. Although small at the time, it would one day ship its products worldwide. Under one roof, the structure served as a brewery and warehouse, as well as retail space for a while. Caught by the camera's lens, an exuberant group of employees gather for a company photograph. (MCHS.)

Around 1848, Jacob Best Sr. moved his retail operation to this storefront. At this location, he sold his brewery's products of vinegar, whiskey, and beer. According to the second-story sign, Jacob Sr. and company also had a wholesale wine and liquor business. During this time, the "company" referred to the partnership between his sons Phillip, Lorenz, Charles, and Jacob Jr. (MCHS.)

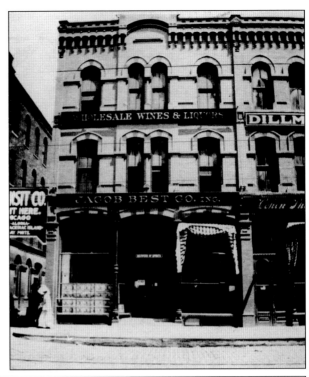

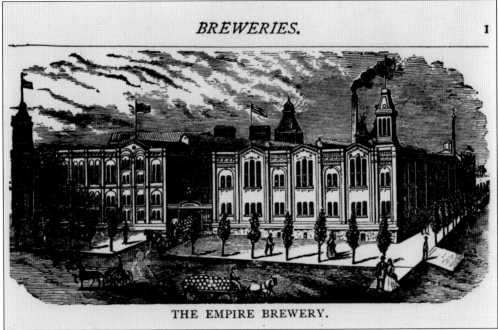

Retooling the brewery to accommodate the shift to beer production brought its own challenges and rewards. Meeting the demands of national markets required enlarging and updating the facility with the latest technology and efficiency. This c. 1877 rendering depicts the plant after the name change to Phillip Best Brewing Company. The image typifies plant size and architecture of the era. (MCHS.)

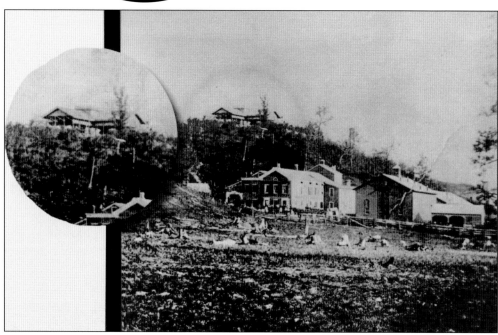

Charles Best (pictured), along with brothers Jacob Jr., Phillip, and Lorenz, assisted his father, Jacob Sr., in the daily function of the family brewery. But when issues arose and personalities clashed, Charles left and started his own brewery down the road in 1850. Naming his enterprise the Plank Road Brewery, Charles was sole proprietor until Lorenz joined him. (MCH.)

This earliest known image of the Plank Road Brewery, from around 1860, highlights the cliffside beer garden. Unable to go it alone after the death of Lorenz, Charles shut down the brewery and moved to Illinois. Foreclosed and sold at auction, Frederick Miller purchased the abandoned site for $2,370 in 1856. (MCMA.)

Prior to the Civil War, American finance was in a state of flux; along with the South's secession, the country was in total financial chaos. The disordered currency supply prompted many states and banks to mint their own. Addressing the issue, merchants minted their own currency in the form of tokens. Distributed by the thousands, businesses hoped to draw in patrons. This beer token is from the Plank Road Brewery. (SHC.)

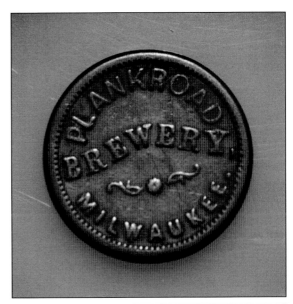

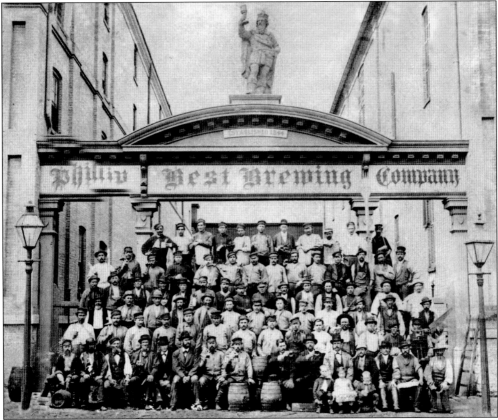

Around 1880, brewery employees gather for a company photograph. Capturing the essence of the brewery, everyone is included: executives, coopers, wagon drivers (or teamsters), and barn help. Above the arch stands the original statue of Gambrinus, considered by many to be the patron saint of beer and breweries. (MCHS.)

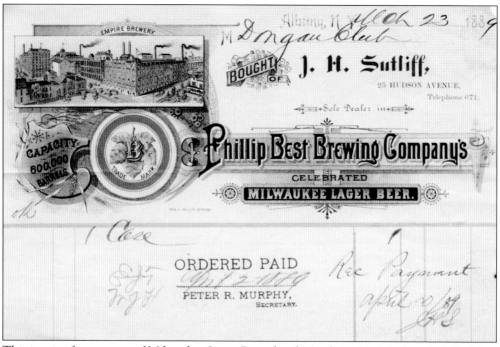

This invoice for one case of Milwaukee Lager Beer, dated March 23, 1889, is from J.H. Sutliff, a distributor in Albany, New York, who at the time was the sole bottler and dealer for Phillip Best Brewing Company products in upstate New York. The beauty and reverence of Pabst products, seen even in this simple invoice, exemplifies how important image was. The upper-left corner depicts the large, modern Empire Brewery plant. (MCHS.)

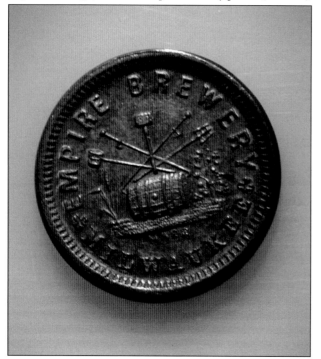

Civil War tokens were used as legal tender, but only in the place of business pressed on the token. This beer token was minted by Empire Brewery in 1863. The back, shown here, depicts a keg surrounded by hops, wheat, and various brewery implements. The front displays a foaming mug with the words, "Phillip Best Lager Beer." Brewery tokens are highly desirable and collectable. (SHC.)

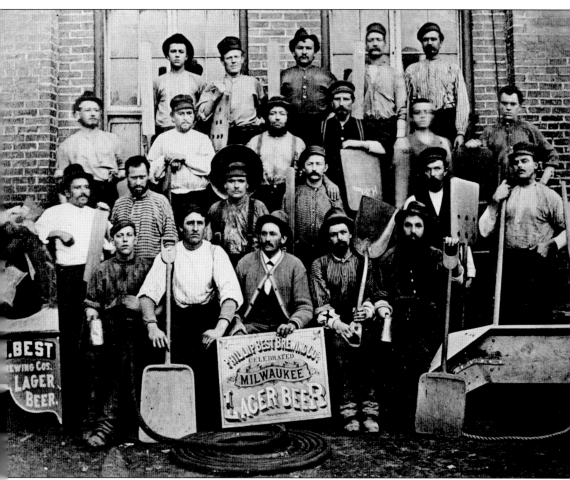

Displaying the tools of their trade, a group of maltsters gather for this 1860 photograph outside the Phillip Best Brewing Company. Specifically involved in the early stages of brewing, maltsters prepared the malt from grain. A very rigorous day's work, Maltsters shoveled the swollen grain onto the growing floor to start the germination process, a very time-consuming and laborious job. Note the variety and size of the shovels used in the process. (MCHS.)

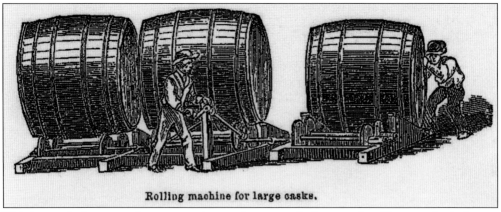

Rolling machine for large casks.

This image depicts a wooden contraption used to move the large casks of lager to the icehouse. Holding approximately 300 gallons of brew, moving such massive vats required careful logistics. (MCHS.)

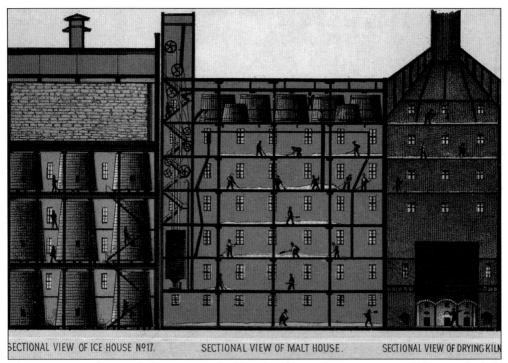

SECTIONAL VIEW OF ICE HOUSE N°17.    SECTIONAL VIEW OF MALT HOUSE.    SECTIONAL VIEW OF DRYING KILN

The amazing workings of a brewery involved stacks of ice to keep giant vats of beer cool while lagering. In the malt house, large cisterns soak grain until it swells; the grain is then flushed down to the couch (a frame to spread barley on) and piled 12 to 16 inches deep and stored to germinate. Maltsters then turn the germinated grain out onto the floor to vegetate for two weeks and finally send it to the kilns to dry. (MCHS.)

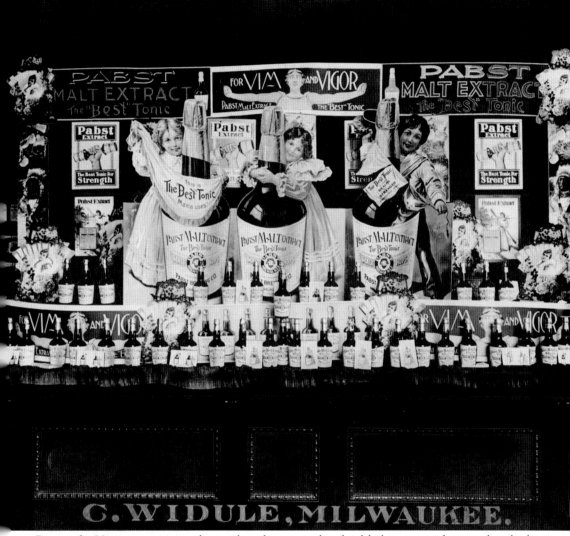

During the Victorian era, new ideas and products regarding health, hygiene, and proper diets had become the rage. This display for Pabst Malt Extract Tonic at G. Widule's pharmacy in Milwaukee promotes the benefits of malt tonic for health and strength, "for vim and vigor," and a feeling of well being and good for the entire family. (MCHS.)

The purchase of C.T. Melms's Menomonee Brewery by Pabst and Schandein marked a pivotal point for the growth of the plant. A second location gained direct water access and a bottling house. Considered the oldest Milwaukee brewery at the time, Phillip Best Brewing Company's new South Side Brewery played a critical role in the plant's future expansion. To the right of the brewery stands the Melms mansion, which Emil Schandein remodeled and lived in for 10 years. (MCHS.)

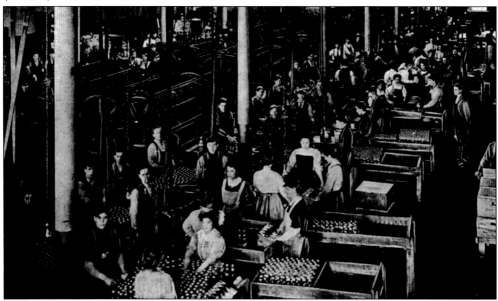

This late 1890s bottle room image depicts an average day at the brewery. In what resembles a human assembly line, men and women work the line together. Men appear to be doing the hefty lifting, while women apply the labels. Female dexterity was highly regarded, giving women ample employment opportunity in this "man's world." Notice the machinery behind the line of men, undoubtedly extremely noisy, which probably led to eventual hearing loss. (MCHS.)

*Five*

# VALENTIN BLATZ

Born in Miltenberg, Bavaria, Germany, in 1826, Valentin "Val" Blatz spent his teen years working in his father's brewery. He traveled for several years around Bavaria to study the techniques of experienced brew masters. At 21, he returned home to fulfill his military requirement. Fearing for his son's welfare, his father secured a substitute in his place and sent him to America. Blatz arrived in 1849 and quickly secured employment.

After two years of work, Blatz had saved enough capital to invest in himself. The Valentin Blatz Brewing Company opened in 1851, next door to John Braun's City Brewery. Both breweries were located in an area of Milwaukee that would later be known as "brewery row." In what might be considered a stroke of luck, Blatz purchased the City Brewery after Braun's death in a wagon accident while delivering beer in 1852. A year later, he married Braun's widow.

After the merger, the new Blatz Brewery was small, employing just four men and producing only 150 barrels of beer in its first year. Through dedication and vision, the brewery grew as a result of sales outside of Wisconsin, making it the fourth largest in Milwaukee. Shipping beyond Milwaukee and as far as New York had its challenges, particularly broken kegs en route. Blatz solved this problem by bottling his product, the first brewery to do so. In 1875, the brewery was turning out 2,000 bottles a day. By the early 1900s, it was the city's third-largest brewery.

With success comes admiration, and in 1891, Blatz was purchased by a British conglomerate, the Anglo-American brewing syndicate known as the US Brewing Company. The buyout had kept the Blatz management team on, which allowed them to do what they did best: make money. In 1894, the brewery produced 365,000 barrels of beer, and it continued to remain a leader in Milwaukee. When Valentin Blatz died in 1894, he was 68 years old and had been regarded as one of the wealthiest men in Milwaukee. At the time of his death, he had amassed a fortune believed to have been $8 million.

After acquisitions in 1969 and 1996, Blatz continues to have a following. Brewed now by MillerCoors for Pabst Brewing Company, Blatz still calls Milwaukee home.

Valentin Blatz immigrated to America from Germany with knowledge as a brew master. After two years working in various breweries, he had saved enough money to be his own boss. In 1851, Blatz opened his brewery next to John Braun's City Brewery. In 1852, Braun died in an accident, and Blatz purchased the brewery, merged it with his, and married Braun's widow. (MCHS.)

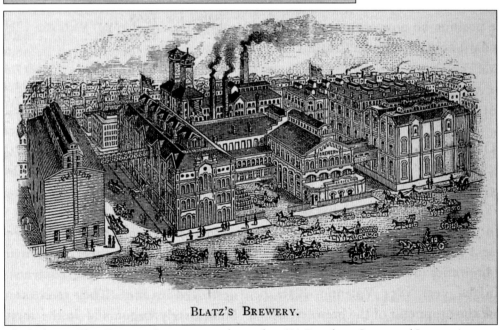

BLATZ'S BREWERY.

The Valentin Blatz Brewing Company was located at 609 Broadway Street and Juneau Avenue. What started as a small enterprise developed through innovation and strong marketing sense into the third largest brewery in Milwaukee by 1900. At the time of Blatz's death in 1894, he had amassed a fortune believed to have been approximately $8 million. (MCHS.)

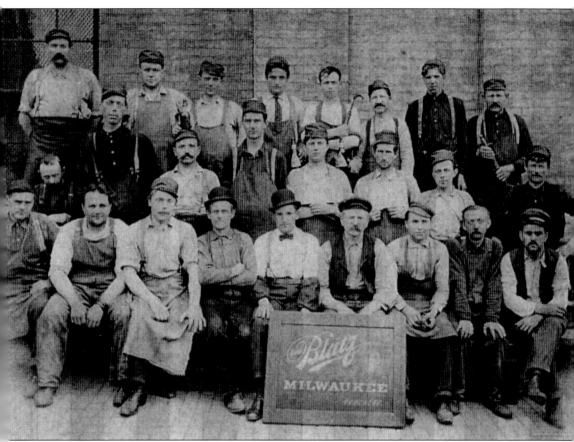

Blatz employees interrupt their work for a few moments to pose for this company picture in about 1897. The men pictured with tools and wearing aprons might possibly be employed in the bottling department. In the third row, third from left, an employee holds a partially filled beer bottle. (MCHS.)

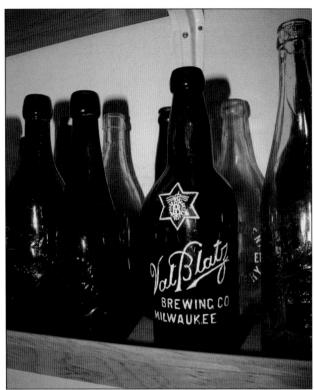

This Val Blatz amber pint bottle was produced by WF&S bottlers. Blatz was Milwaukee's first bottled beer in 1875; in 1880, these amber bottles and Val Blatz's lager were shipped worldwide. (SHC.)

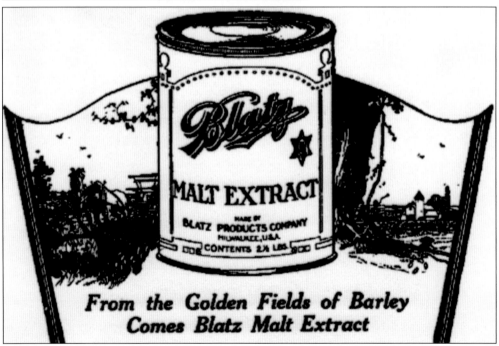

Malt extract was a popular Prohibition product produced by most breweries. Sold in a powder form, malt could be reconstituted and used in the process of home brewing or as a diet supplement, specifically for children, though adults consumed it as well. (MCHS.)

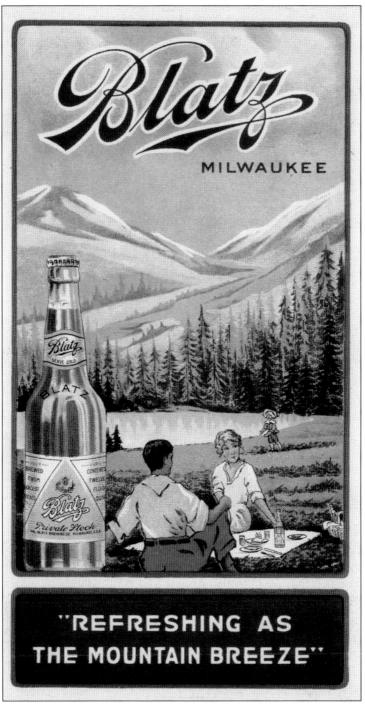

This Blatz window advertisement depicts a serene mountain scene for a family picnic. Clever marketing dispels the negative thinking previously associated with beer. Beer and all alcohol were demonized as the cause of society's ills, claiming it led to poverty, broken homes, and abuse. This advertisement is quite the contradiction, showing a family in harmony, peace, and good times, enjoying nature. (WSHS.)

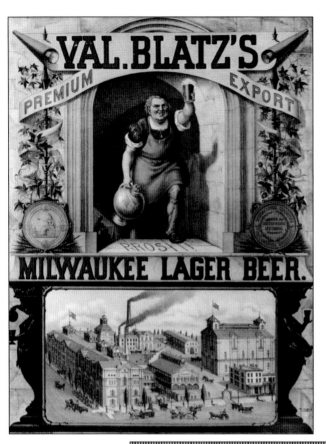

This c. 1879 brewery print advertisement for Val Blatz's Milwaukee Lager Beer depicts a brewer rising from the caves with a jug of lager beer and a full glass. (MCHS.)

This early 1900s advertisement suggests that both mother and baby can benefit from the mother consuming her daily dose of beer. The advertisement claims that malt in beer offers nourishing qualities and hops act as an appetizing stimulant tonic. (MCHS.)

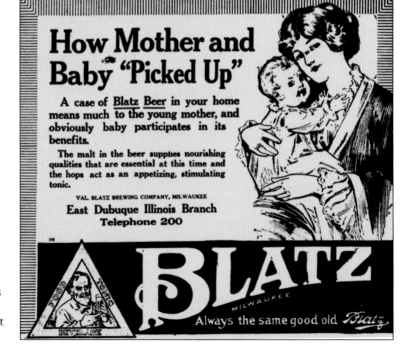

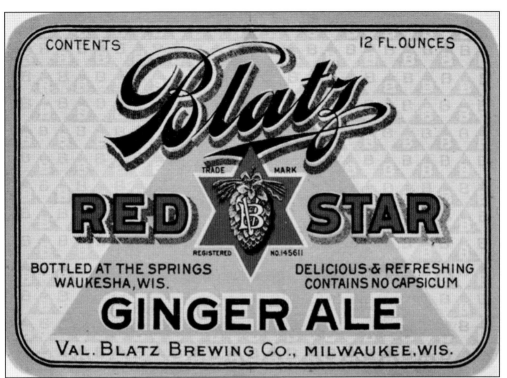

CONTENTS                                    12 FL. OUNCES

*Blatz*

TRADE                                        MARK

RED ★ STAR

REGISTERED        NO.145611

BOTTLED AT THE SPRINGS          DELICIOUS & REFRESHING
WAUKESHA, WIS.                      CONTAINS NO CAPSICUM

GINGER ALE

VAL. BLATZ BREWING CO., MILWAUKEE, WIS.

Prohibition was devastating to all breweries, and to remain competitive, breweries shifted gears, retooled, and produced a variety of products. In this case, as with most breweries, Blatz produced its own soda water in several varieties. Blatz Red Star Ginger Ale was very popular, as was the company's chewing gum and juice. (MCHS.)

Once Milwaukee breweries entered a national market, they adapted new strategies to capture their target markets. Print advertisements were powerful visuals, often featuring celebrities to endorse their products. This 1948 magazine advertisement features Milwaukeean Max Gene Nohl, an adventurer, salvage diver, and inventor of the aqualung, all of which are depicted in the advertisement. (NF.)

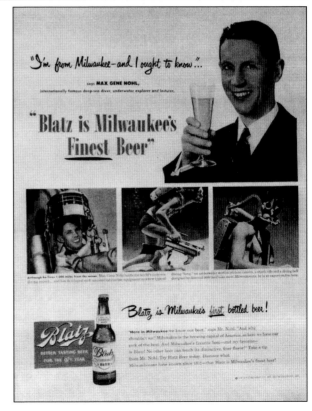

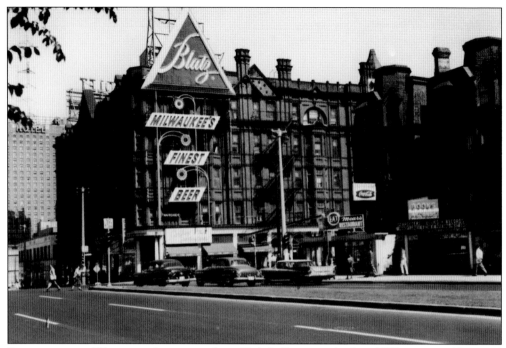

Driving east on Wisconsin Avenue at about Eighth Street in the late 1950s, one couldn't miss this Blatz sign. Five stories high, this sign would have been the first hint of arrival to "Brew City," heading into Milwaukee. This building has survived and is now apartments. (MCHS.)

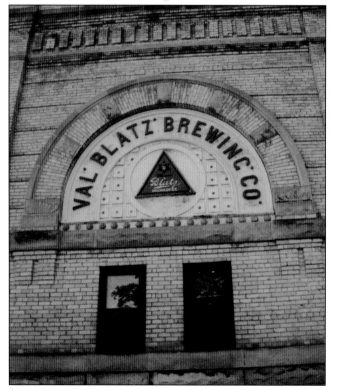

Blatz's plant is much smaller than it was 100 years ago, but the heart of the brewery—its refrigeration building and the main office—have been preserved. The refrigeration building (pictured here) was converted in 1988 to upscale apartments and condos, while the main office is part of the Milwaukee School of Engineering campus. (MCHS.)

# *Six*

# FREDERICK MILLER

Born to a middle-class merchant family in 1824, Frederick Miller, the youngest son, knew his future would be of his own making. After completing his preparatory education, Miller followed the traditional path in search of a brew master's craft.

After studying several years under Bavarian brew masters, Miller made his way to France to apprentice under his uncle. Five years later, he perfected his craft and become a master brewer. Confident, he returned to Germany, where he secured the lease to the old royal brewery and tavern in Sigmaringen and immediately set to work. From the beginning, Miller brewed with passion and implemented high standards. As a result, both tavern and brewery garnered Frederick high praises and a heavy purse. Eventually, realizing the limitations of the small brewery and the desire for something more, Miller arrived in New York in 1854.

Armed with determination and a small fortune, he devoted his first year investigating potential regions for settlement and selected Milwaukee. Miller could have chosen any city, but he selected Milwaukee specifically for its Lake Michigan access, long cold winters essential for proper fermentation and storage of beer, and the large population of German-born consumers thirsty for lager beer. Shortly after his arrival, Miller found the fully equipped but abandoned Plank Road Brewery. Too good to pass up, he bought it. Production began immediately; the fall of 1855 produced the first Miller Brewing Company kegs.

As expected, Miller's passion, expectations, and hard work were rewarded with growing sales and faithful customers. Taking advantage of rail and steam vessels, he shipped his product far and wide to meet demand. As successful as he was in business, his private life met with unexpected sorrows. Several children died unexpectedly, as did his wife, Josephine. Within a year, Miller married Lisette Gross, a brewer's daughter from Franklin, Wisconsin. The union produced five children who would later assume their role in the company. Guided by faith and family, Frederick Miller was able to find happiness and the strength needed at this time in life. With his family and through his faith, the following years proved to be his best.

Frederick, youngest of the Miller sons, was raised in a life of privilege, but knew, due to his birth order, he alone would be responsible for his success. Miller followed the traditional path in search of a brew master's craft. When he had perfected his craft, he headed for America. Arriving in 1854 with his wife, Josephine, and young son, he set out immediately to explore Milwaukee's opportunities. (MCMA.)

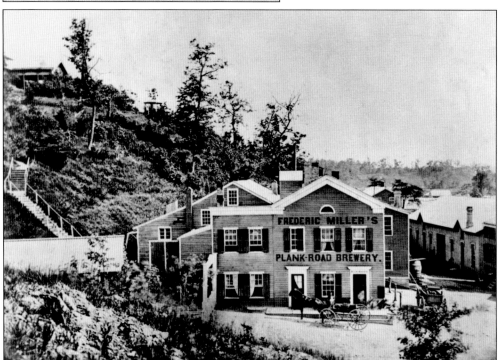

This is an 1867 photograph of Frederick Miller's Plank Road Brewery after he purchased Charles Best's abandoned plant. Located in the Menomonee Valley, just a few miles west of Milwaukee, this image shows considerable plant improvements, as well as the remodeled beer garden on the hill. Barely visible, the beer garden was an added marketing ploy to bring patrons out beyond city limits to enjoy Miller's products. (MCHS.)

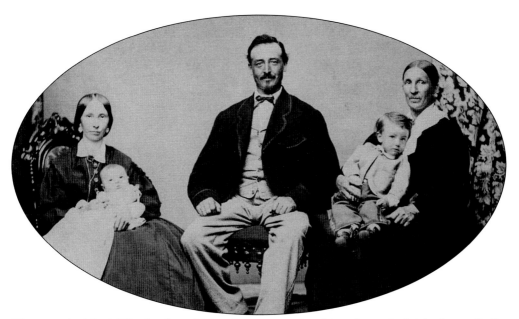

The arrival of the Miller family in Milwaukee promised nothing short of a bright future. Sadly, the death of his children and wife, Josephine, dealt Frederick a heavy blow. Eventually, he was charmed by Lisette Gross, the daughter of a Franklin, Wisconsin, farmer and brewer. After a short courtship, the couple married. Pictured here around 1868 are, from left to right, Lisette, holding Fritz; Miller; and Lisette's aunt, Anna Gross, holding Ernest. (MCMA.)

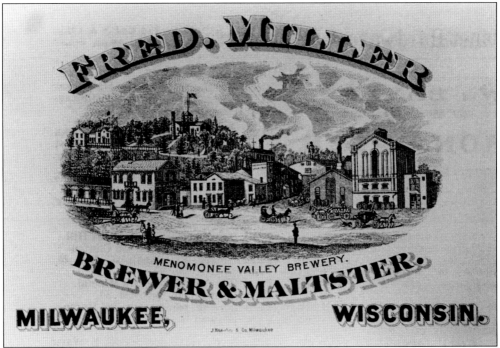

This c. 1875 lithograph shows the major improvements to the Menomonee Valley brewery. To the right of the original Plank Road Brewery is the new brew house, which operated on steam power. Implementing new technology was essential in keeping ahead of the competition. (MCHS.)

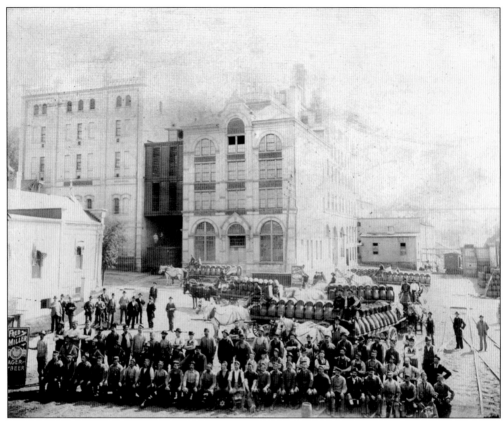

With wagons loaded (pulled by teams of draft horses), bottlers, coopers, office personnel, and executives gather for a photograph in front of the brew house at Fred Miller's brewery in about 1892. This picture was taken in front of the brewery complex, located on State Street in the Menomonee Valley, where it continues to brew beer today. The rail spur to the right was essential in reaching national markets. (MCMA.)

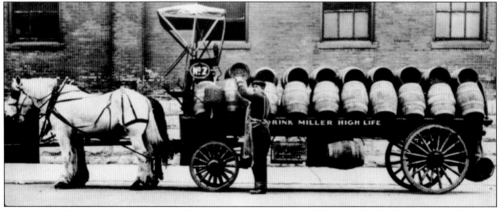

For local deliveries before the use of auto trucks, wagons did the job. Pulled by teams of horses, teamsters delivered barrels of beer to taverns. These strong, patient, docile animals were the powerhouses of the brewery. Not just any horse would do; large, heavy, draft horses, such as Percherons, got the job done. This photograph was taken around 1900. (MCHS.)

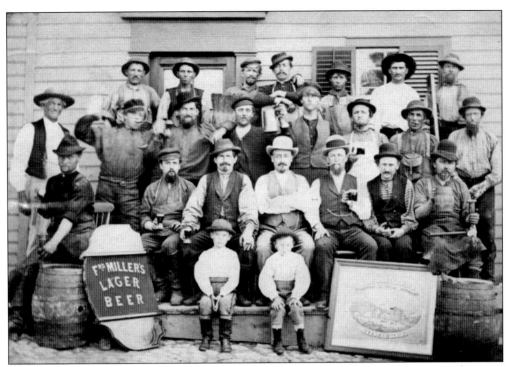

In this c. 1880 photograph of Frederick Miller (center with bowler hat), he poses with a select group of employees, possibly coopers. Note that many of the men hold a mug of beer, a fringe benefit for brewery workers. All the beer a man could drink was offered free for the asking. (MCMA.)

On the death of Frederick Miller in June 1888, his sons Ernest (pictured), Frederick A., and Emil shared an active part of brewery management, but Ernest held the president's chair the longest. Together, they brought the brewery into the 20th century. Expanding the brewery structure would allow for growth and updated technology. In 1890, Miller Brewing Company generated its own electricity used for lighting. (MCMA.)

Frederick A. (left) and Emil Miller spent their adult life in some capacity at the brewery. At times, sisters Clara and Elise also managed the brewery as well. Soon, another generation would take its place when sister Clara's son Frederick C. Miller came on board to direct the company in 1947 after World War II. (MCMA.)

Grown immensely since the early days, the brew house and stock house, shown in the 1945 photograph below, were the first buildings developed during the initial brewery's growth in the 1880s. Both of these buildings are now part of an even larger complex in Miller Valley. Still the heart of the brewery, these buildings now house the utilities for the Milwaukee Brewery. (MCMA.)

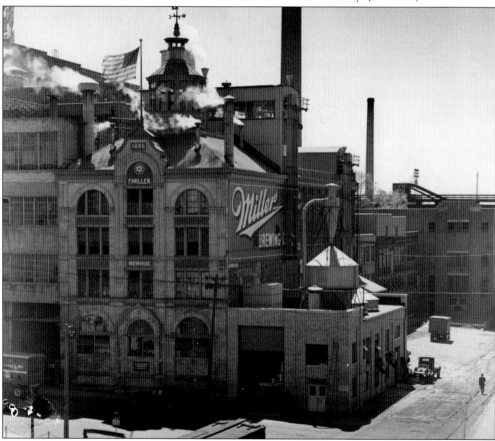

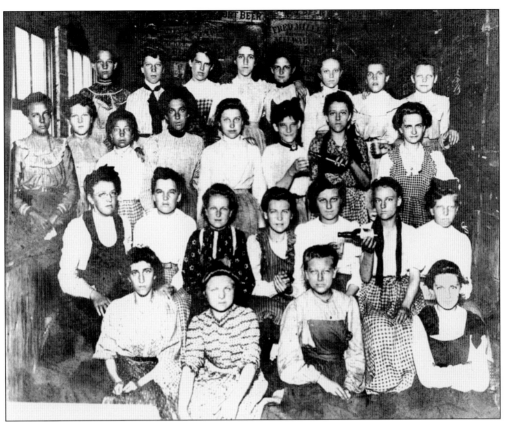

Women from the bottling plant pose with some of their wares. At the time of this c. 1902 photograph, most brewery employees in Milwaukee were unionized, except the female employees in bottling houses. That changed after labor activist Mary Harris, nicknamed "Mother Jones" campaigned for female employee rights. Admitted into the union in 1910, the women had won a pay raise and shorter workweeks. (MCMA.)

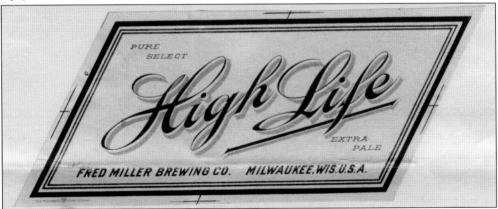

The year 1903 marked Miller's introduction of its High Life brand. Coincidently released in the same era that America's leisure class was developing, this new beverage, enjoyed in the company of good friends and fine food, would reinforce the consumers' own image. Everything about this brand, including a bottle change resembling a champagne bottle, gave way to Miller's new slogan in 1907, "The Champagne of Bottle Beer." (MCMA.)

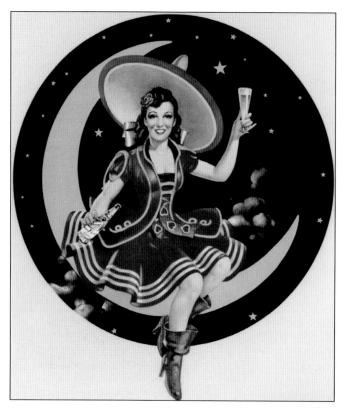

This Miller High Life girl dates all 1940s or later marketing material. She appears only in reproduction material, including mirrors, plates, trays, posters, and more. Over time, the images have been updated ever so slightly, so as not to detract from her appearance. There has been much discussion on whom she is modeled after; some believe it was Miller's daughter or granddaughter, but none of these rumors have ever been confirmed. (MCMA.)

Often referred to as the "Girl in the Moon," the Miller High Life girl is the creation of A.C. Paul, the Miller Brewing Company advertising manager. First appearing in 1907, she has become a legend in the brewing industry as well as an advertiser's dream. The Girl in the Moon is one of marketing's most recognizable images of all time. (MCMA.)

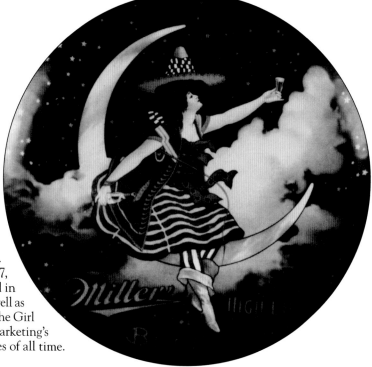

On January 16, 1920, Prohibition went into effect. As a result, the manufacture, sale, and transportation of intoxicating liquors was outlawed, but not its consumption. To hold on to customers, Miller introduced its special near-beer product. Containing less than one half of one percent alcohol by volume, the advertisement promises the same refreshment without the alcohol. (MCMA.)

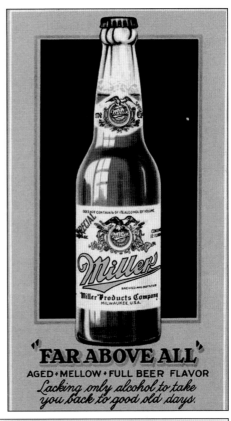

During Prohibition, Miller Brewing Company, like every other brewery in the United States, turned to the production of soda and malt extract. By the end of Prohibition, Miller was more stable than many of its competitors, as its investments outside the brewery included both residential and commercial real estate; however, it was looking forward to life after Prohibition. (MCMA.)

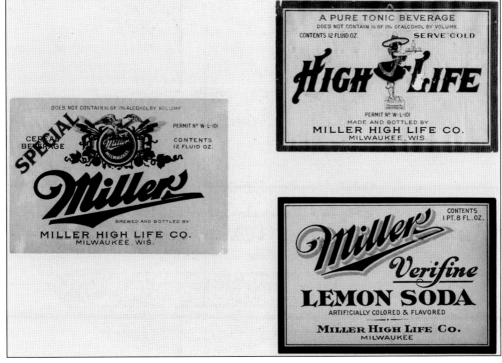

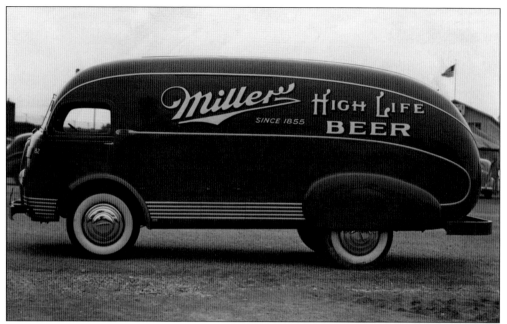

Breweries were one of the first industries to implement change as a means to stay ahead of competition. Influenced by the Art Deco style, the custom, streamlined body of this c. 1949 Miller truck delivered to wholesale customers. Designed by Brooks Stevens and built by Dodge, this whitewall solid-tire truck was produced in a limited quantity and is rarely seen restored. (MCMA.)

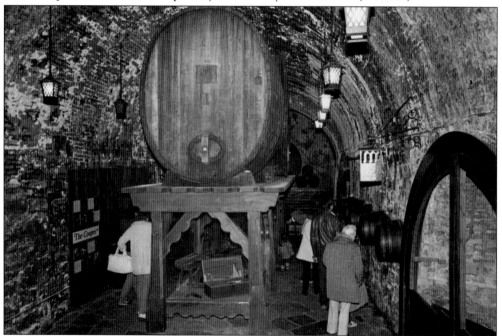

Some of the oldest features of the Miller Brewing Company complex are the original storage caves. Dug into the cliffs overlooking Miller Valley, the caves were closed after the refrigerator building was constructed. Reopened in 1953 as a museum, the caves draw thousands of visitors every year. The immense interior illustrates just how many kegs of beer could be stored here. (MCMA.)

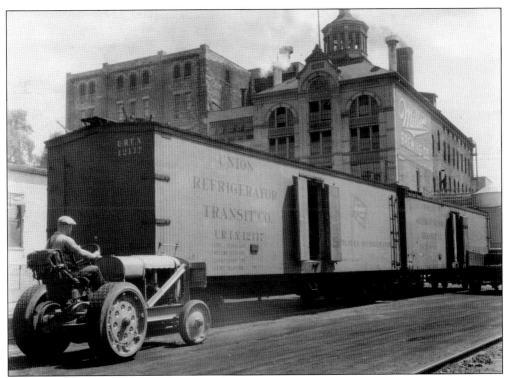

Every brewery had a rail spur, and Miller was no different. Rail, the most efficient mode of shipping during the 1930s, was faster and less costly than before. The brewery employee in this 1934 photograph is navigating a boxcar into the rail yard for loading. At one time, this boxcar would have sported a brewery color scheme and logo, but that had recently become forbidden because of Prohibition. (MCMA.)

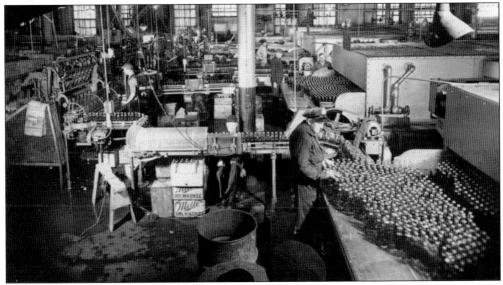

Technology played a vital role in brewery production, as well as employee workload and performance. The bottling room at Miller Brewing Company went from 30 or 40 employees per shift in the late 1890s to a dozen or so, as evidenced in this 1940s photograph. (MCMA.)

After World War II, men came home, and life changed for them and the country. A new middle class living in suburbia was emerging. Returning veterans wanted to experience the high life, and not just in their beer. A new advertising campaign catered to this modern lifestyle and the sophistication of suburban living. (MCMA.)

Designed by Brooks Stevens, the High Life Cruiser was used as a promotional tool, traveling cross-country to mark the 50th anniversary of Miller High Life beer. Stevens (right) shows Fred Miller some of the interesting aspects of his Miller cruiser. (MCMA.)

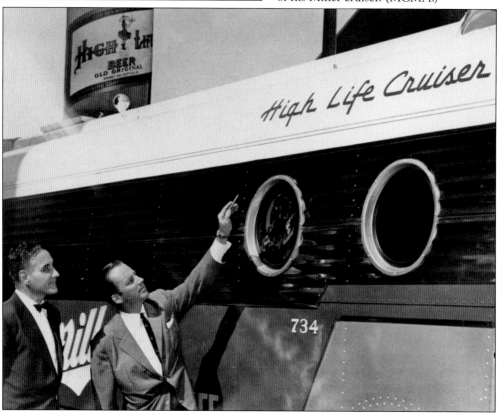

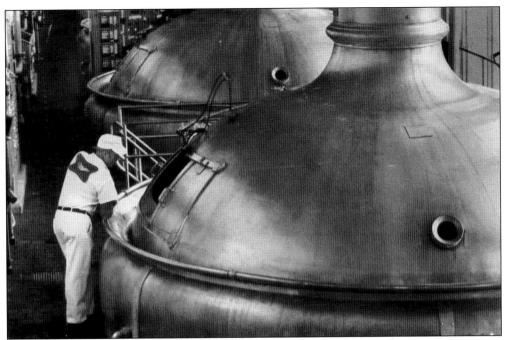

This postcard shows Miller employees checking brew kettles in the brew house. For almost 100 years, Miller used copper kettles, but maintenance issues eventually resulted in an upgrade to stainless steel. (MCMA.)

Appealing to the health consciousness of young Americans, Miller developed a low-calorie beer. Endorsed by athletes and marketed as a beer that was refreshing with one-third less calories, the light beer movement projected Miller ahead of all its competitors. The "Great Taste, Less Filling!" campaign rolled out in 1975. (MCMA.)

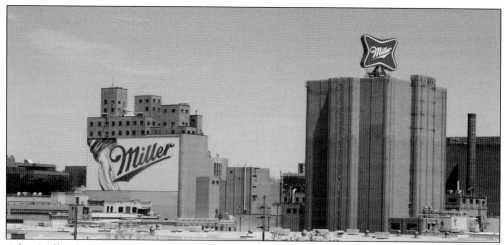

After Miller family members sold their interests in the family business, the brewery changed hands several times. Most recently, in 2008, it formed a joint venture with Molson Coors to become MillerCoors, with brewery operations in Milwaukee (pictured) and Golden, Colorado, and company headquarters in Chicago. (APC.)

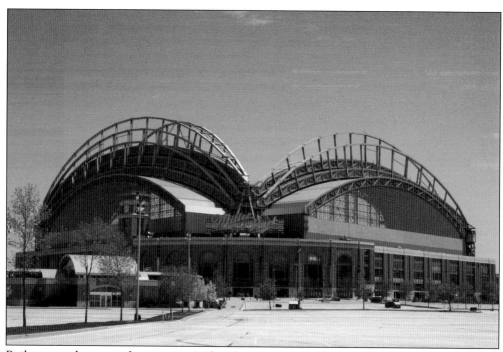

Built as a replacement for an aging Milwaukee County Stadium, Miller Park was unveiled in 2001, just in time for opening day. Home to the Milwaukee Brewers, the stadium truly is art in motion, with its sweeping retractable rooflines. The crown jewel of Milwaukee's skyline, Miller Park is proud to bear the Miller name above its entry. (APC.)

# Seven

# FREDERICK PABST

Unbeknownst to Frederick Pabst, he would call Milwaukee home twice in his lifetime. His family immigrated from Nikolausrieth, Germany, in 1848 and settled first in Milwaukee before moving to Chicago. To support his family, Pabst worked odd jobs until he became a cabin boy on a Great Lakes steamer. Pabst sailed Lake Michigan hauling cargo and passengers for seven years before gaining his pilot's license and his own ship. Pabst assumed command of the *Comet*, a side-wheel steamship more dependent on passengers than cargo. It was during one of these excursions that Pabst rescued a passenger who had fallen from the ship. Little did Pabst realize he had rescued his future bride, Maria Best, the daughter of Phillip Best.

Shortly after that episode, they married, and Pabst continued to sail Lake Michigan until a winter storm beached his ship. Heeding the close call, Pabst decided he was safer on land and seized the opportunity to buy into the Phillip Best Brewing Company in 1864. Pabst's good business sense soon increased product output to one million barrels a year. Experiencing failing health and the grip of old age, Best offered Pabst and his brother-in-law Emil Schandein an opportunity for greater control when they bought out their father-in-law in 1866.

The partnership of this dynamic duo resulted in an expanded market share outside Milwaukee, and by 1874, Phillip Best Brewing Company was on its way to become the largest brewery in the United States. Though the brand never won a blue ribbon, it did win gold. As a marketing ploy, Pabst tied blue ribbons around the bottlenecks to distinguish its brand from others, forever to be known as Pabst Blue Ribbon.

The death of Schandein in 1888 triggered several changes for the brewery, including a name change. In 1889, Pabst felt the time was right for the introduction of the Pabst Brewing Company. Pabst always had a keen sense of product image on a national scale and developed new ways to reach consumers. His national marketing campaign included Pabst hotels, restaurants, and tied houses—saloons "tied" to a specific brewery—in every major city. When Pabst died in 1904, he had established quite an empire.

Frederick Pabst immigrated to Milwaukee in 1848 from Nikolausrieth, Germany, with his family to seek a better life. After a short time in Milwaukee, the family moved to Chicago, where all three members worked to support the family. After his mother's death, Pabst signed on as a cabin boy on a Lake Michigan steamer. For 10 years he sailed the waters of Lake Michigan between Chicago, Milwaukee, and Michigan's coast. (MCHS.)

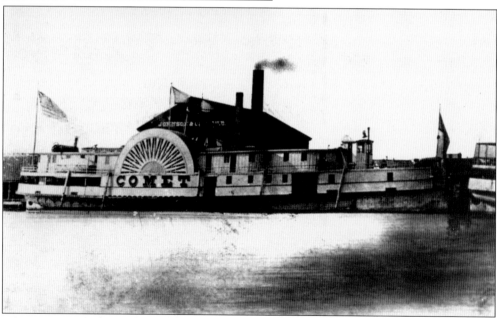

Pabst had sailed Lake Michigan hauling cargo and passengers for almost 10 years when he assumed command of the side-wheel steamship *Comet* in about 1860. On one particular voyage, as the story goes, Pabst rescued a passenger who had fallen from the ship. Unbeknownst to him at the time, he had rescued his future bride, Maria Best, the daughter of Phillip Best. They were married two years later in 1862. (MCHS.)

As was common for the period, a high rate of infant mortality affected Milwaukee families, and the Pabst family was no different. Unfortunately, only five of Frederick and Maria's ten children survived to adulthood. After the death of their oldest daughter Elizabeth, Maria and Frederick adopted Elizabeth's daughter Emma Marie. Pictured here with her grandparents, "Elsbeth," as she was nicknamed, lived in the Pabst mansion until old enough to attend boarding school in Europe. (PM.)

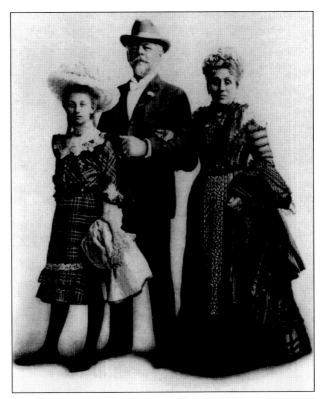

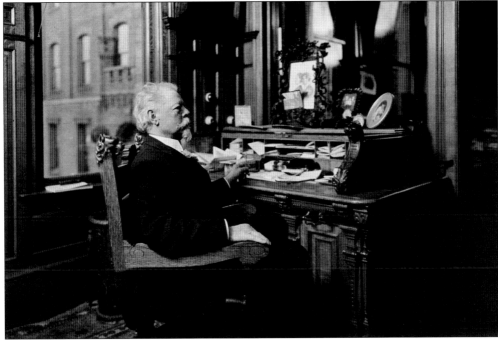

Captain Pabst, seen in this undated photograph, is caught in mid-thought. His desk, rumor has it, was positioned strategically so that he could glance from his window and, with a sweeping view, watch the daily activity of his competitors and friends Schlitz and Blatz. (MCHS.)

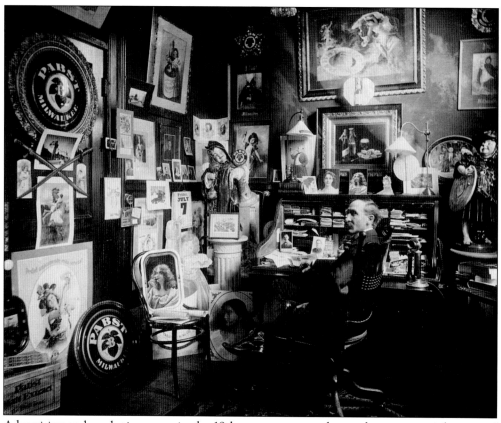

Advertising and marketing, even in the 19th century, was understood as an essential aspect of business. As seen in this 1898 photograph, Joseph R. Kathrens, the advertising manager of Pabst Brewing Company, seems to be quite content amongst the clutter of his brand. (MCHS.)

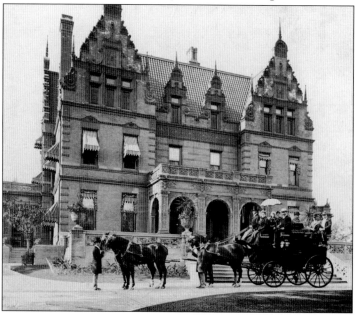

After their marriage, Maria and Frederick lived in a small home a short walk from the brewery. Ever reminded of his position in a worldwide company, Pabst built a home more befitting a brewery president on Milwaukee's prestigious Grand Avenue. Built in 1892 at a cost of $254,614, the 20,019-square-foot mansion has five levels, 37 rooms, 10 bathrooms, and 210 windows. Today it is one of Milwaukee's most treasured structures. (MCHS.)

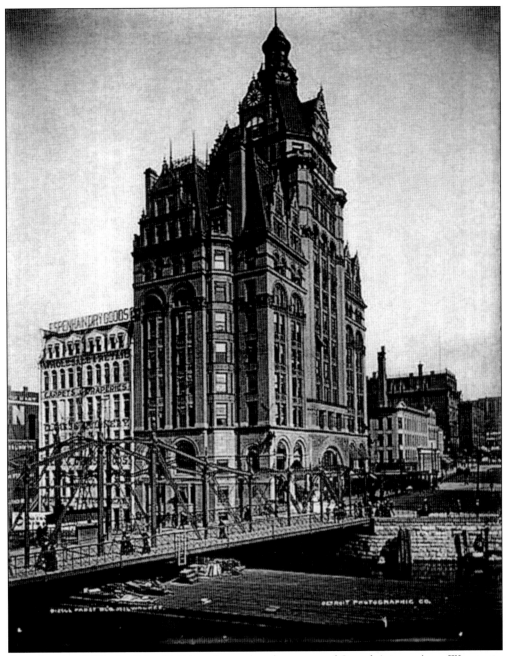

Completed in 1893, the Pabst Building, located at the corner of Grand Avenue (now Wisconsin Avenue) and Water Street, was the grandest building in the city at that time. The structure was 13 stories tall with grand entrances at street level. Razed in 1981 to make way for a modern structure, the Faison Building, almost an exact reflection of the Pabst Building, was erected on the same spot in 1989. (MCHS.)

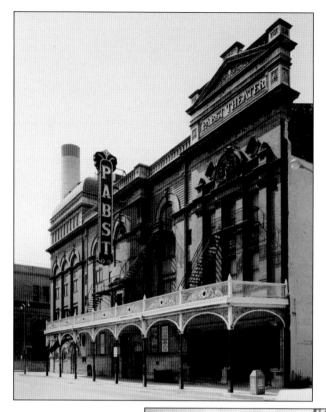

Rebuilt after a fire destroyed the Stadt Theatre, the new Pabst Theater opened in 1895. Designed by Otto Strack in the traditional German opera house style, the opulent theater reflected a German Renaissance Revival influence. The theater, built to be the most fireproof building in the city, is the fourth-oldest continuously operating theater in the United States and has been designated a National Historic Landmark. (MCHS.)

Concerned with developing new opportunities to enhance the image of Pabst Brewing Company on a national scale, Pabst invested heavily in real estate. For Pabst, image was everything, and in November 1899, a grand nine-story Hotel Pabst opened in New York City. Chicago, Minneapolis, and San Francisco hosted Pabst restaurants, hotels, and tied houses as well. (MCHS.)

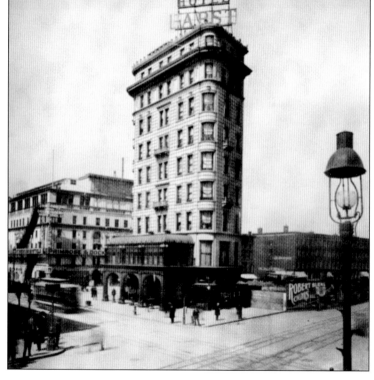

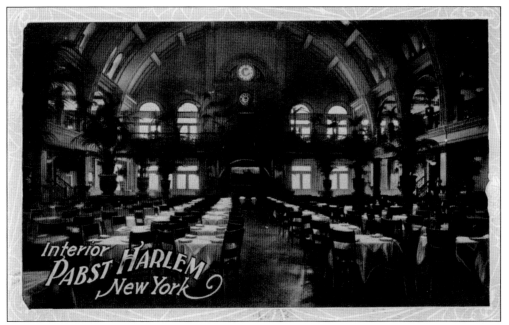

Concerned with brand visibility, Pabst set out to conquer New York. He already had two hotels, and added this restaurant. Opened in September 1900, the Pabst Harlem was billed as the largest restaurant in America. It could accommodate 1,400 customers at a time. (JH.)

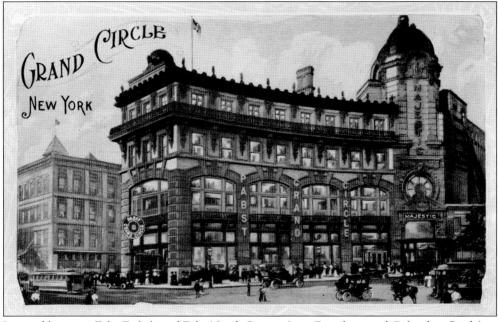

Located between Fifty-Eighth and Fifty-Ninth Streets (now Broadway and Columbus Circle) in New York, the Pabst Grand Circle Hotel opened on January 20, 1903. The restaurant was located at the south end of this spectacular building, while a new Majestic Theatre was located on the north end. It was razed in 1950. (JH.)

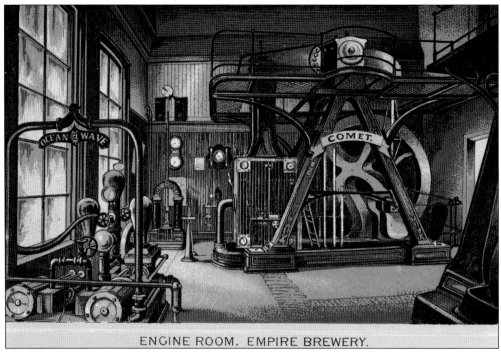

ENGINE ROOM. EMPIRE BREWERY.

Pictured in this c. 1867 lithograph is the engine room, the powerhouse of the plant, which supplied steam throughout the brewery. Note the name *Comet* on the engine, a nod to Captain Pabst's lake steamer. (JH.)

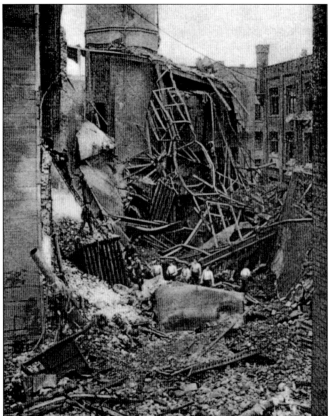

Steam generated from the engine room can be very dangerous. Taken in October 1909 at the Milwaukee plant, this photograph shows the aftermath of a boiler house explosion. One worker was brutally maimed, while another was buried and eventually found dead. The power behind the blast scattered debris hundreds of feet and left twisted beams of metal amongst the rubble. (MCHS.)

An unknown lithograph company is examining the final print of a Pabst Brewing Company advertisement. From 1885 to 1910, Milwaukee was a hub for printing. During that era, there were over 100 lithograph companies in the city, publishing everything from German-language newspapers, city directories, and billboards. (MCHS.)

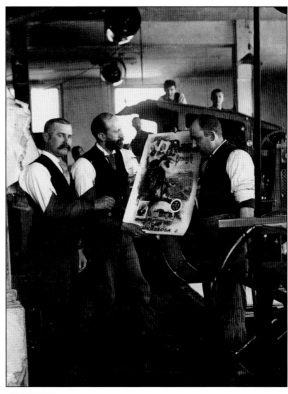

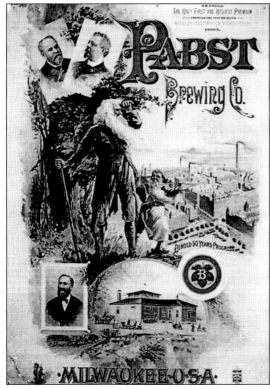

Seen here is the actual poster being proofed by the lithograph employees above. Note that the poster reads "Pabst Brewing Co.," with inset images of Jacob Best (bottom left), Emil Schandein (upper left), and Frederick Pabst (upper right). A barely visible watermark date of 1894 celebrates 50 years of brewing. (MCHS.)

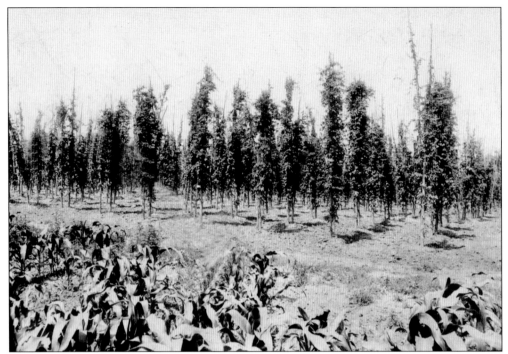

Several reasons Milwaukee was chosen as an optimum brewery site include the presence of fresh water, the location, and the surrounding farmlands. Pabst Brewing Company was one of the few breweries that purchased its hops, barley, and oats locally. As a result of the breweries, secondary businesses sprang up—in this case, a hop farm. Grown on a standing pole, hops can reach 20 feet or more. Once they ripen, the vines are cut and the hops dried. (MCHS.)

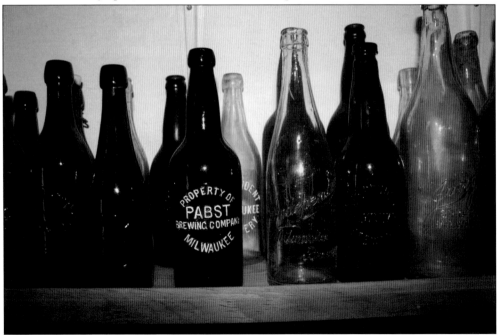

Dated between 1889 and 1900, this Pabst amber pint was bottled by WF&S. (SHC.)

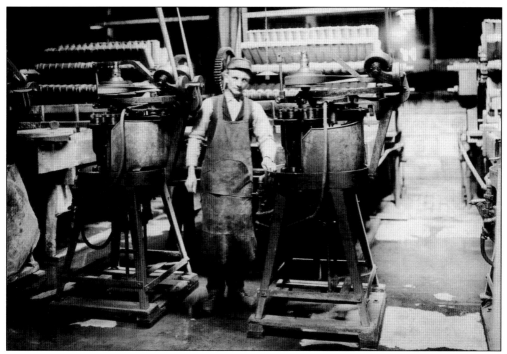

In this image captured in the Pabst bottle house in 1915, an employee takes a welcomed break. The introduction of bottled beer was a direct result of frequently damaged kegs transported via rail. (MCHS.)

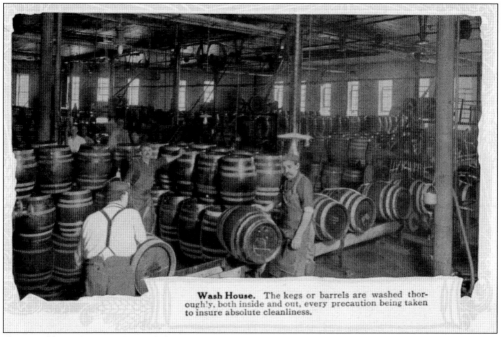

**Wash House.** The kegs or barrels are washed thorough'y, both inside and out, every precaution being taken to insure absolute cleanliness.

Kegs and barrels were cleaned thoroughly, inside and out, in the washhouse, seen in this c. 1905 image. Every precaution was taken to assure the cleanliness of the barrels before reuse. The manual labor needed for a day's work in early breweries was extremely exhausting. (JH.)

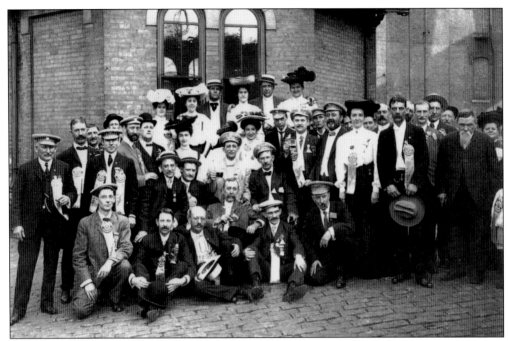

By the late 1890s, Milwaukee had become quite the tourist destination. A thriving convention center brought many diverse attendees, and as today, many enjoyed Milwaukee's hospitality, beer gardens, brewery tours, theaters, and countless hotels and restaurants. This delegation of Modern Woodmen of America agents were caught at the end of the Pabst brewery tour. Mugs in hand, these visitors seemed to be enjoying themselves. (MCHS.)

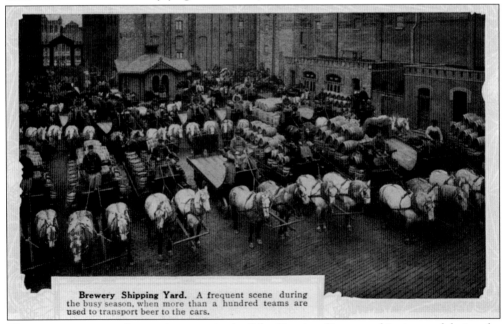

**Brewery Shipping Yard.** A frequent scene during the busy season, when more than a hundred teams are used to transport beer to the cars.

This was a common early-morning scene in the Pabst Brewing Company shipping yard during the busy season, with more than 100 wagon teams preparing to transport beer to the railcars. Teamsters and their teams wait for the signal to roll out with the barrels in this c. 1905 image. (JH.)

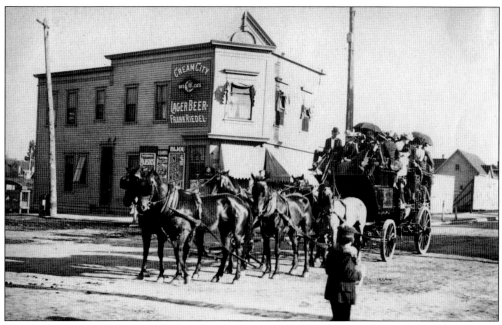

A group of tourists arrive in Milwaukee by stagecoach for a day of fun and beer. Marketing outside Milwaukee required creative thinking. Savvy marketing and advertising in addition to great products brought tourists in from all over. Tied houses offered free lunch with a five-cent beer. Great Lakes steamboats carried travelers and visitors to Milwaukee, and then stagecoaches shuffled them to the breweries. Breweries built beer gardens that provided music, food, and family entertainment. Milwaukee became a tourist destination. (MCHS.)

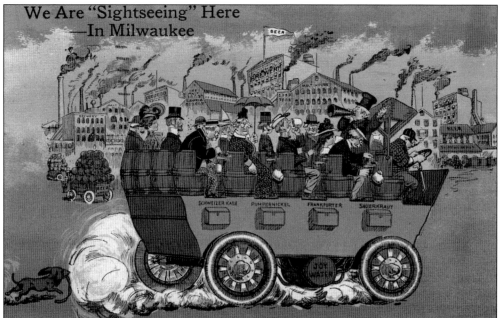

This 1933 tourist postcard depicts the image of the above photograph. There are several versions of this image, but all reflect Milwaukee's tourist draw. The wagon highlights a day of fun and good food: "schweizer kase," "pumpernickel," "frankfurter," "sauerkraut," and of course, "joy water" (beer). (APC.)

SELECT.

Originally named Best Select, then Pabst Select, this brand was chosen as "America's Best" at the World's Columbian Exposition in Chicago in 1893. But not until January 1898 did the blue ribbon label first appear. Initiated as a marketing ploy by Pabst, blue ribbons were tied around bottlenecks to imply an exceptional product. Patrons clamored for the "blue ribbon beer." The practice continued until a silk shortage during World War I. (MCHS.)

A group of employees gather for this photograph in front of a Pabst brewery boxcar. The use of rail allowed breweries to distribute their product nationwide. Convenience of a brewery's own rail spur made for better efficiency in loading boxcars. Usually painted with the brewery's colors, this car also shows the Pabst logo. Considered moving billboards, the boxcars were made illegal after Prohibition. (MCHS.)

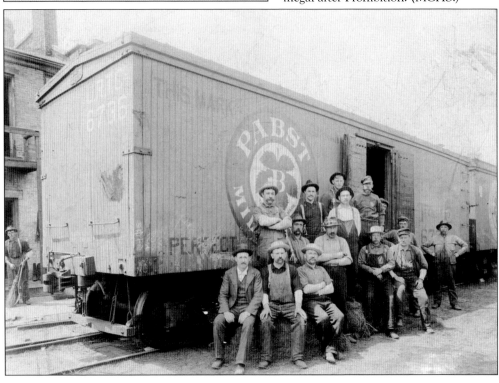

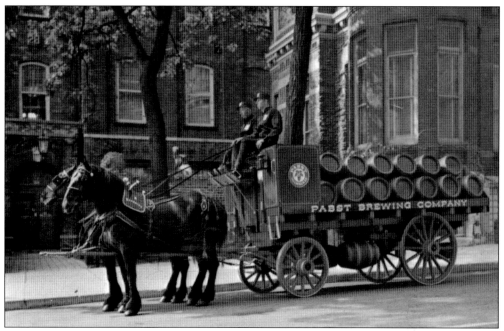

Pictured is a perfectly preserved original Pabst Brewing Company wagon from the 1880s, as depicted on a 1960s postcard. At the time, the wagon was used primarily for publicity and would have been driven by two teamsters and pulled by a team of Percherons. (JM.)

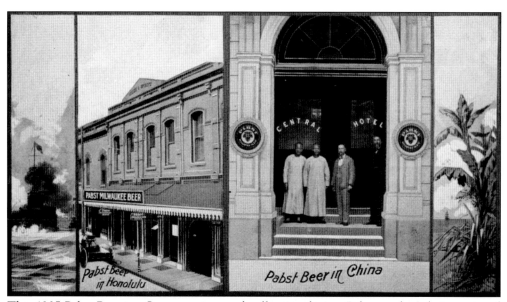

This 1905 Pabst Brewing Company postcard collection depicts Pabst products being enjoyed in all parts of the world. From Mexico to the Philippines to China, Pabst brought the taste of Milwaukee across the globe. (JH.)

On March 12, 1889, the brewery name changed to Pabst Brewing Company. By 1900 this Pabst logo, the initial "B" lying on a hop leaf within a red circle, appeared on thousands of buildings coast to coast, like this one above the Milwaukee plant's main office door. Honoring the brewery's roots, the logo pays tribute to the brewery's founder, Jacob Best Sr. (APC.)

Gambrinus is considered the patron saint of breweries and beer. Conflicting stories have circulated regarding his origin and contributions; some believe he learned the art of brewing from Isis, while others believe he was a trusted cup handler in the court of Charlemagne or a king. This handsome Gambrinus sits in the courtyard of Best Place, on the grounds of the original Pabst Brewing Company plant. (APC.)

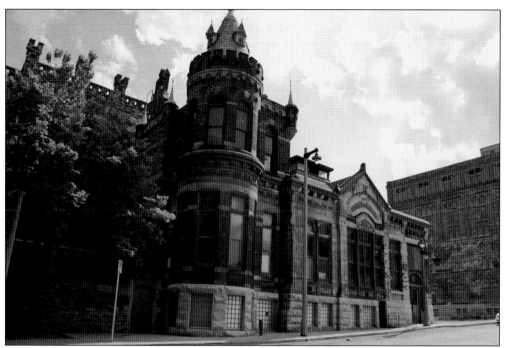

Many of the original buildings have faced redevelopment and reuse, but many Pabst Brewing Company buildings and offices still stand. From the turreted windows 123 years ago, Captain Pabst could look out over the most successful companies in the world, headquartered in Milwaukee. This building still stands, one corner in history, the other in a new future. (APC.)

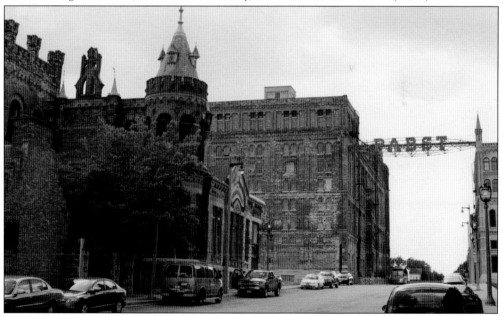

Driving west on Juneau Avenue takes one under the iconic Pabst sign, where the road ends. The road might end there, but Pabst's story lives on. The Pabst Brewing Company has experienced some neglect over the years, but investors are redeveloping the property as a mixed-use project. The old hustle and bustle is back, now bigger and better than ever. The captain would be proud. (APC.)

Seen here is the Mill House, built in 1891, and the Pabst smokestack, just before demolition in 2008. Located at Juneau Avenue and Highland Boulevard, the 20 acres of buildings have stood in the same place for over 150 years. A mixed-use development along with building renovations will bring new vitality to this area. (JS.)

The most iconic brand to come out of the Pabst Brewing Company is Pabst Blue Ribbon, or PBR, as it is more commonly known. Originally called Pabst Select, it took five gold medals at the World's Columbian Exposition in Chicago in 1893. To draw attention to the beverage, blue ribbons were tied around the necks of the bottles. Thinking they were special products, customers clamored for the blue-ribbon bottles, and the rest is history. (MCHS.)

# Eight

# JOSEPH SCHLITZ

Joseph Schlitz Brewing Company originated as the August Krug Brewery in 1849. Driven by political unrest, George August Krug fled Bavaria and headed to Milwaukee to seek his fortune. Wasting no time, Krug quickly established the Menomonee Hotel. Five years later, Krug's father immigrated with his grandson August Uihlein and the family fortune. The funds were invested in a brewery addition and three new employees, including Joseph Schlitz, as bookkeeper. In 1856, Krug died, and Schlitz became manager, purchasing the brewery a year later and eventually marrying Krug's widow, Anna Maria. He later changed the name of the brewing company to the Joseph Schlitz Brewing Company.

Schlitz expanded plant operations and targeted new market areas. Several of August Krug's Uihlein nephews, now employed in various capacities, helped the brewery to become one of the most prominent of its time. One opportunity in particular helped Schlitz make a name for himself and Milwaukee: the Great Chicago Fire.

On the night of October 8, 1871, fire swept through the city of Chicago, burning for three days, killing hundreds, and taking with it a quarter of Chicago's homes and business district. The aftermath was disastrous; the fire had tainted the entire city's water supply, including Lake Michigan. As an offer of support, Schlitz stepped up and donated trainloads of beer to the survivors; it was the only thing to drink. Chicago accepted this gesture of goodwill and, grateful, celebrated Schlitz. Before any local breweries could rebuild, Schlitz captured the city's beer market. Later, the slogan "The beer that made Milwaukee Famous" was adopted for use in all marketing aspects.

At the age of 44, Joseph Schlitz lost his life in a shipwreck off the coast of England, transferring leadership to the Uihlein brothers and allowing them to continue their Schlitz business strategies. They eventually gained complete control upon the death of Anna Schlitz. Under their leadership, the company implemented the use of the brown bottle in 1912 and crown-sealed spout-top cans in 1935.

Confident the brewery would continue to do well under his nephews, Schlitz's will mandated just one request: never change the brewery name. To this day, the product is brewed under the Joseph Schlitz name.

August Krug's inn and brewery was the foundation for one of the world's largest breweries. From the humblest beginnings, Krug's brewery excelled, and once his family joined him, it did even better. The Uihlein nephews, along with Joseph Schlitz, guided the brewery into the 20th century. This grave marker stands in Forest Home Cemetery of Milwaukee as a testament to Krug's subtle, strong, and enduring impact. (MCHS.)

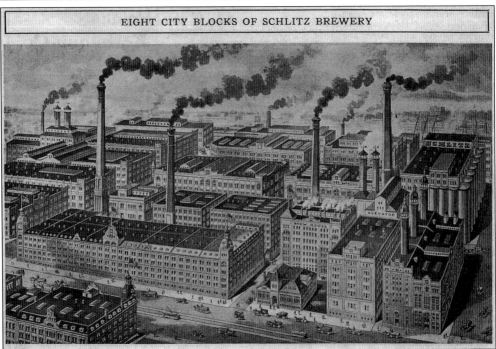

Established in 1849 as a small inn and brewery by August Krug and his wife, Anna, it had grown into a world-class brewery and had once been the largest producer of beer in the world. It is amazing to think that the original brewery only produced 150 barrels its first year. Dated approximately 1890, this lithograph depicts the size of the plant. Spanning eight city blocks, it was a community unto itself. (MCHS.)

Joseph Schlitz, a native of Mainz, Germany, immigrated to Milwaukee in 1850 when he was 19. Experienced in bookkeeping, he was hired on at August Krug's brewery. After Krug's death in 1856, Schlitz purchased the business, married Krug's widow, changed the brewery name to Joseph Schlitz Brewing Company, and then went on to brew "the beer that made Milwaukee famous." (MCHS.)

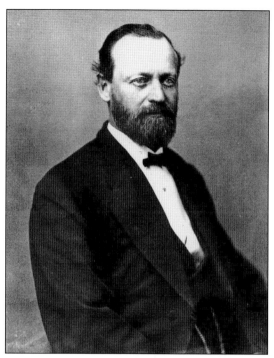

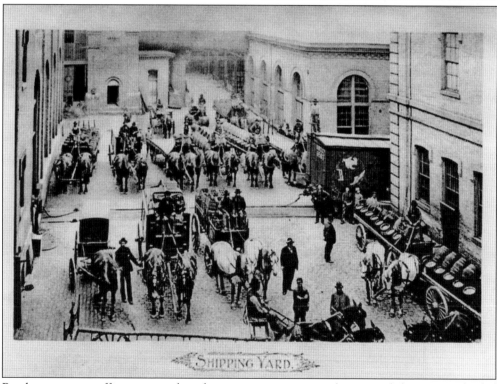

Bottlers, coopers, office personnel, and company executives gather around the wagons, loaded to the hilt with beer barrels and pulled by teams of draft horses, for a photograph in the brewery yard at Joseph Schlitz Brewing Company around 1880. (MCHS.)

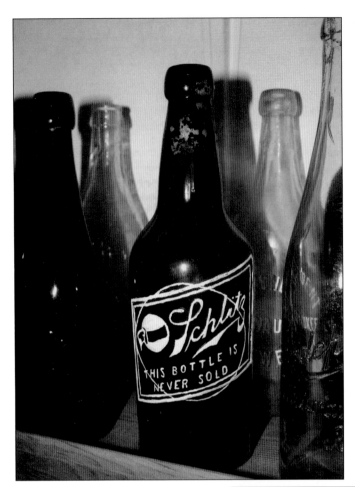

This early Schlitz brown bottle is an amber pint with no bottle maker noted. The term *brown bottle* came from the original tasting room at the Schlitz brewery, which opened in August 1938 as the Brown Bottle Pub, offering good will and the original-recipe Schlitz on tap. (SHC.)

This Civil War token was issued by Joseph Schlitz Brewing Company, due to the lack of government-issued currency. Only redeemable in a Schlitz tavern, the token was good for one mug of beer. Dated somewhere between 1860 and 1865, this Schlitz token is the same on both sides, which is somewhat unusual, as most tokens included the brewery name on one side and a brewery logo on the other. (SHC.)

THE GREAT FIRE AT CHICAGO. OCT: 8TH 1871.

Preceded by weeks of dry weather, a ravenous fire swept through the city of Chicago on the evening of October 8, 1871, consuming everything in its path. Fanned by high winds, the fire worked its way through the city for two days until rain helped volunteers and firefighters extinguish the flames. The disaster left 300 people dead, thousands homeless, and leveled the entire central business district of Chicago. (MCHS.)

The aftermath of the Great Fire not only left Chicago in ruins, it also destroyed the city's water system and polluted Lake Michigan. Moved by the devastation, Joseph Schlitz donated thousands of barrels of beer to the citizens of Chicago. Touched by the generosity of its neighbor to the north, Chicago welcomed the refreshment and thankfully praised Schlitz and his brew that "made Milwaukee famous." (MCHS.)

177—Drake's Block, Cor. Wabash Ave, and Washington St.

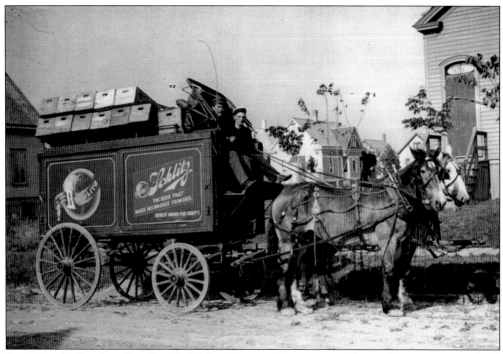

Servicing the local market, Joseph Schlitz Brewing Company used horse-drawn wagons to haul beer to the many brewery saloons and tied houses in Milwaukee. This wagon, loaded to the top with product, bears the belted globe logo and Schlitz signature label. Conscious of the brewery's image, wagons were well cared for, and the horses were always clean and presentable. (MCHS.)

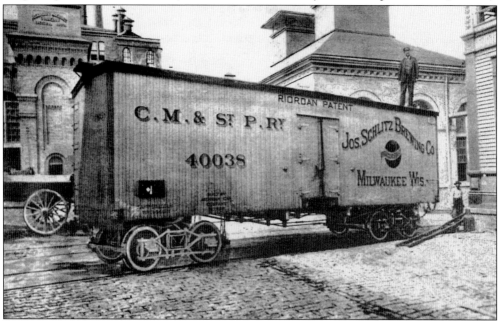

Rail service opened new markets from coast to coast, requiring diverse logistics to deliver the product on time and with little damage. This refrigerator railcar from 1866 is 50 feet long and adorned in white with black lettering and the brown Schlitz logo. (MCHS.)

In 1850, when August Uihlein was eight years old, he and his grandfather George Krug sailed for America. What should have been an adventure turned nightmarish when their ship caught fire and sank, leaving August and his grandfather adrift. After their rescue, they arrived in Milwaukee to assist in August Krug's brewery. Eventually, the Uihlein brothers would become the executive team to bring what would become Joseph Schlitz Brewing Company into the 20th century. (MCHS.)

The Uihlein brothers, nephews of August Krug, pose for this 1889 executive photograph. From left to right are Charles, August, William, and Alfred. The Uihleins learned the brewery business as young boys in the family brewery in Germany. Each brought their own talents when they joined their uncle, as well as later when they became the management team at Joseph Schlitz Brewing Company. In particular, they utilized innovation with superior business sense and drive to make Schlitz a world-renowned brewery. (MCHS.)

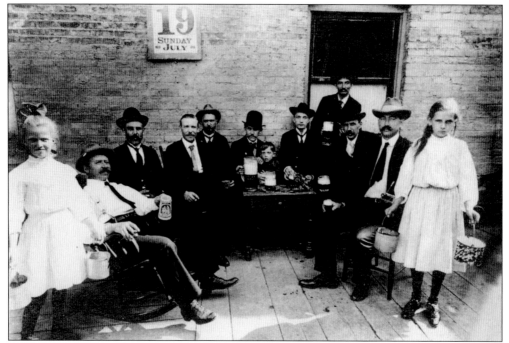

It was not uncommon to see children around industrial areas. Many factories employed children because of their size and dexterity; they could fit between, behind, and inside machines. These girls, delivering buckets of beer to employees on a beer break, were known as "growlers." They would fetch the beer and sell it to employees in many different industries. Today, a growler is a takeaway 64-ounce bottle of beer. (MCMA.)

With the help of a barrel-stacking machine, several barrel types are ready to be loaded and shipped in this 1937 photograph. In the background to the left stand several aluminum kegs, differentiated by their middle band. The center barrels are of metal, and those in the foreground are wood. (MCHS.)

Employees of the Schlitz Bottling Works pose for a picture outside the plant. The c. 1910 pickup truck would have created quite a stir for these four men, who are pleased to have their photograph taken with a modern marvel. (MCHS.)

Too much beer was not always a good thing. This photograph from 1942 shows the aftermath of a Schlitz brewery building collapse. This old tannery building, used for bottle storage, gave way due to age and the weight of the cases of bottles. (NCHSA.)

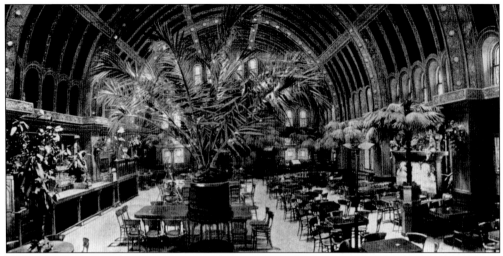

Developed to draw faithful customers and lure new ones, breweries invested in hotels, restaurants, theaters, and beer gardens, each trying to outdo the other. The Schlitz Palm Garden exemplified all the flourish and grandeur of the mid-Victorian era. Serving Milwaukee for 25 years but unable to survive Prohibition, the Palm Garden closed on March 6, 1921. Eventually, the site was sold and developed for the Grand Avenue Mall in 1981. (MCHS.)

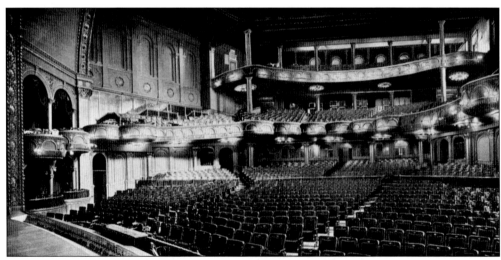

The Alhambra (originally the Uihlein) Theatre was the first major movie house in Milwaukee in 1896. A product of the Gilded Age, the theater featured fabulous opulence. The tri-level auditorium included 3,000 seats and 18 private boxes, briefly making it the largest movie theater in the world. Initially featuring vaudeville and traveling performance groups, the theater introduced movies in 1898. Plagued by years of instability, the theater closed in 1960. (MCHS.)

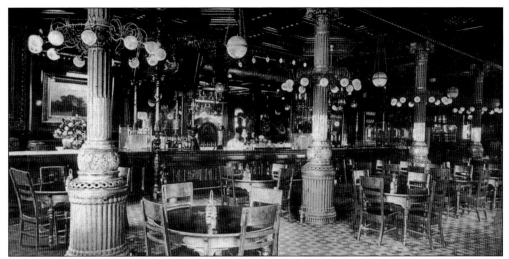

The barroom at the Schlitz Hotel did a rather brisk business from both locals and tourists. Interior shots reveal the palatial atmosphere of the room, making every customer feel special; imported marble, exotic wooden trim, and plenty of seating encouraged patrons to linger. As beautiful as this barroom was, it was unable to serve enough nonalcoholic beverages during Prohibition to survive, forcing the business to close. (MCHS.)

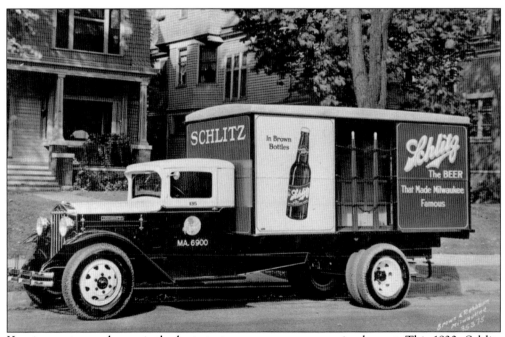

Keeping customers happy is the best strategy any company can implement. This 1930s Schlitz delivery truck is parked outside a customer's home while the driver makes a delivery. Home delivery of beer: what a concept. (MCHS.)

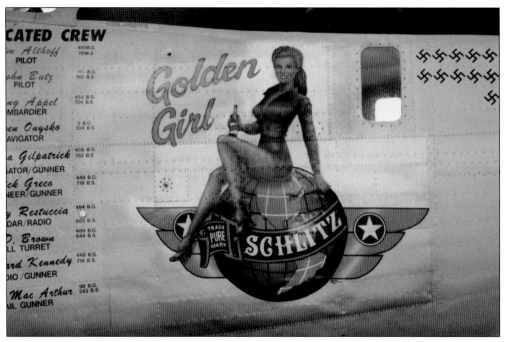

Aircraft graffiti, or nose art, is decorative painting on the fuselage of military aircraft. This World War II B-24 Liberator sports the Schlitz "Golden Girl" atop the belted globe. Part of the Collins Foundation's flying museum, sponsored by Schlitz, these vintage bombers, restored to flying condition, are on tour at various airfields across the country. The foundation exhibit salutes veterans and their families who have sacrificed so much. (APC.)

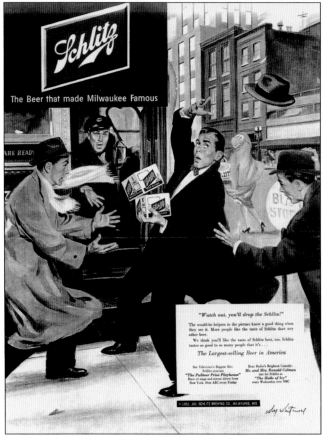

From the "Series of Mishaps" prints, this 1951 advertisement depicts the importance of "rescuing their favorite beverage" at all cost. The four men from various backgrounds all agree on one thing: save the Schlitz. (MCHS.)

Intended to create brand loyalty, breweries supported local taverns by advancing startup costs and financing improvements and fixture purchases. Seeking a better profit margin, breweries also invested in tied houses. Brewery specific, tied houses became the direct line to customers by cutting out the middle man. This one-time Schlitz tied house is now the Three Brothers restaurant, continuously operated for over 50 years by the Radicevic family, featuring an Eastern European menu. (APC.)

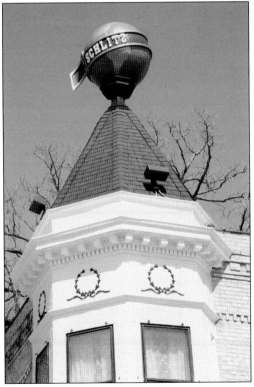

Tied house locations were strategically chosen to showcase a brewery brand. Located on street corners, the building featured an angled entry facing an intersection crowned by the brewery logo. Built in 1897, this Schlitz tied house, featuring the belted globe, has withstood the test of time. Located on Milwaukee's south side in historic Bay View, this treasure has been listed in the National Register of Historic Places. (APC.)

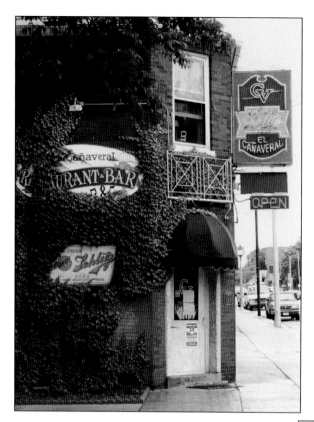

Another well-preserved and popular tied house, built in 1904, is Little Schlitz, located at 2501 West Greenfield Avenue in Milwaukee. A traditional tavern with neon signs, Little Schlitz, now the El Canaveral, featuring a Mexican cuisine menu, has been a neighborhood icon for over 100 years. After Prohibition, the term *tied house* was phased out, and corner establishments were then termed bar and grills, taverns, or cocktail lounges. (APC.)

"Drink Schlitz regularly—every day—for health and enjoyment," read the advertisements for Schlitz's Vitamin D beer. Researchers at the University of Wisconsin, Madison, developed a technique to increase Vitamin D in foods and promoted the process to market more nutritious foods. Schlitz capitalized on the idea and included fortified Vitamin D in its product. Not very profitable, the short-lived beverage was available from 1936 to 1938. (MCHS.)

# New in New Orleans!
# Schlitz in 7oz. ruby bottles

● Now for the first time, you can get Schlitz in the new 7 oz. ruby bottle which holds just enough beer to fill one glass right to the top.

You'll know this little gem of a bottle by its distinctive ruby color and the red, white, and gold foil label.

It's a wonderful way to have *one full glass* of the beer that tastes so good to so many people that it's *the largest-selling beer in America*.

*Actual size*

## The Beer that made Milwaukee Famous

*Holds exactly one glassful— no more, no less*

Advertising was not only for selling products but also for publicizing new ones. With a test market in New Orleans, this 1950 advertisement announced the new seven-ounce bottle from the Joseph Schlitz Brewing Company. The Ruby Red bottles, made by Anchor Hocking, were produced from 1950 to 1963. Cited as too costly, the bottles were discontinued. Ruby Reds are extremely rare, given their short production time, and very collectable. (MCHS.)

Advertising and promotions covered all media aspects. During the 1950s, corporations cashed in on the popularity of radio and television. From short commercials to full sponsorships, branding was born. WTMJ, an NBC-affiliated Milwaukee television station, featured the *Schlitz Saturday Night Theatre*. Schlitz sponsored a movie with live singing commercials before, during, and after the movie. On board for the fun were, from left to right, Robert Uihlein, Jack Brand, and unidentified. (MCHS.)

The Schlitz facility, purchased in 1983 by investors for redevelopment, is shown in the midst of deconstruction. While several buildings were saved for revitalization, others were razed. These storage tanks in the stock house, dwarfing the construction workers, show what an immense undertaking it was. (MCHS.)

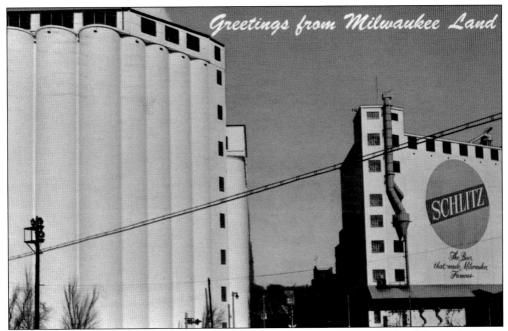

A tourist postcard from 1963 shows the Schlitz plant in its heyday. To the left are the grain elevators. Note the Schlitz sign depicting the globe and belt. With its advantageous location, this site frequently lent itself as the canvas for the current advertising campaign. (APC.)

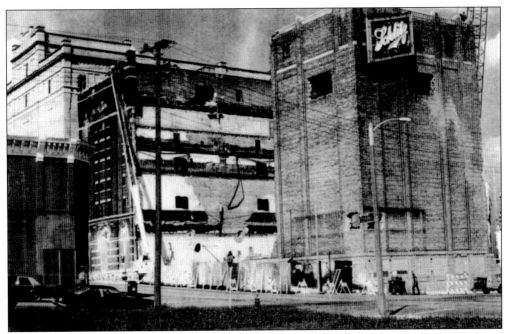

Heavy equipment makes short work of age-old buildings around 1980. The Schlitz Park demolition began with the brew house, followed by strategic building demolition for safety and the remodeling of others for preservation. The park would become a multiuse complex, including offices, housing, and retail space. (APC.)

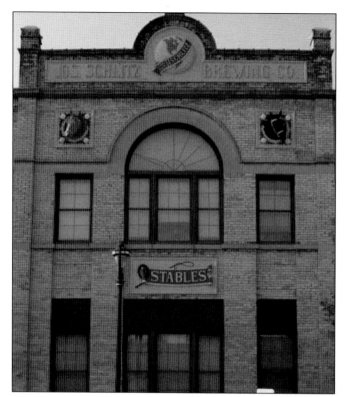

The Schlitz Brewery Stables, located at Walnut and Second Streets, housed over 100 horses that served in various capacities at the brewery, mainly hauling barrel-filled wagons. Percherons were most likely the selected breed. The building, now used for offices, still features two three-dimensional horse heads; perhaps they were used as a sign for non–English speaking employees or were just an extravagant aspect of the stables. (APC.)

The Joseph Schlitz Brewing Company stock house, located on Third Street (now M.L. King Drive), was built in 1886 in the German Renaissance Revival style. Originally erected with multiple onion-shaped towers capped with lighted cupolas, only one remains. It was constructed with the distinct Cream City brick native to southeastern Wisconsin. When the red clay is formed and fired, it turns a creamy yellow. (APC.)

# Nine

# PROHIBITION

The temperance movement began in the late 1800s and surged in the early 1900s. Members nationwide banded together in an attempt to alter, if not eliminate, personal habits and behaviors deemed detrimental to society—in this case, drinking. Issues such as domestic violence, abandonment, poverty, and lack of moral fortitude, all blamed on drink, fueled the movement.

Initially, the Woman's Christian Temperance Union (WCTU) lobbied for alcohol restrictions at the local level (blue laws), but their sheer numbers encouraged broader legislation. Their ultimate goal was a prohibition amendment to the US Constitution. Although Milwaukee was a beer town, social issues and the lean toward a socialist government gained the temperance movement a foothold in the city. Empowering itself, the WCTU aligned with the Anti-Saloon League (ASL).

The ASL's influence spread rapidly, becoming the most powerful single-issue lobbying organization in America. They targeted saloons and tied houses in every city. Located on almost every corner in Milwaukee, tied houses were the neighborhood social clubs. Seen as a moral threat, their days were numbered.

On January 16, 1920, the 18th Amendment went into effect. Prohibition became law; the manufacture, sale, and transportation of intoxicating liquors was outlawed, but not its possession or consumption. Once again, Milwaukee was brewing, but this time, it was bathtub gin, moonshine, and more. Speakeasies replaced the corner saloon. Jennie Jano, the "Queen of Bootleggers," and Maryann Kwapiszewski, the "Moonshining Momma," were two industrious women meeting public demand. Jano catered to the college crowd, while Kwapiszewski concentrated on out-of-state sales. As the demand rose, production grew more organized and squeezed out the little guy. Profits were skyrocketing, and production became dangerous. Thanks to bootleggers, rumrunners, and gangsters, the next 13 years brought more corruption, crime, and lawlessness than ever before—the exact opposite of what the legislation had intended.

Prohibition and its unintended consequences hit Milwaukee hard. Most breweries shut down, tied houses were outlawed, and thousands of workers lost their jobs. A handful of breweries stayed afloat by producing soda water, near beer, malt syrup, candy, and cheese. Through diversification, Blatz, Gettelman, Miller, Pabst, and Schlitz all survived Prohibition.

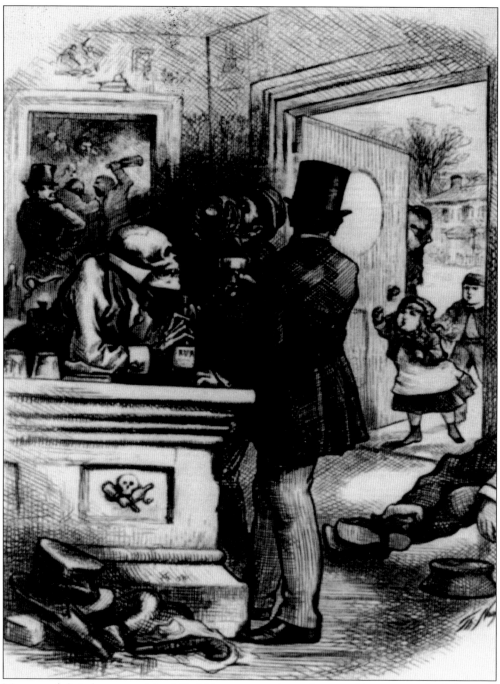

Men were definitely targets of the ASL. Using scare tactics to change public opinion, this lithograph portrays alcohol and the taverns' impact. A skeleton bartender serves poison, a brawl in the back room is uncontrollable, and one man sleeps where he landed. Evidently, the father has stopped so long that his family has come to find him and bring him home. (MCHS.)

Frances Williard, a Wisconsin native, attended the Female College in Milwaukee, where she developed the belief that the negative issues of an urban lifestyle centered on the liquor industry. Campaigning to reform social injustice, women's rights, and temperance, Williard accepted the appointment as president of the Chicago Woman's Christian Temperance Union. As president, she directed campaigns against the liquor industry and organized membership drives and protests. (MCHS.)

This popular poster, distributed by the Woman's Christian Temperance Union, promoted the ratification of the 18th Amendment. Founded in 1874, the WTCU was, and still is, a national organization to help combat what members feel are the destructive effects of alcohol on families. The WCTU quickly became one of the most powerful women's groups of the 19th century, and in the 20th century, it expanded its platform to include anything that it deemed harmful to the traditional family unit. (MCHS.)

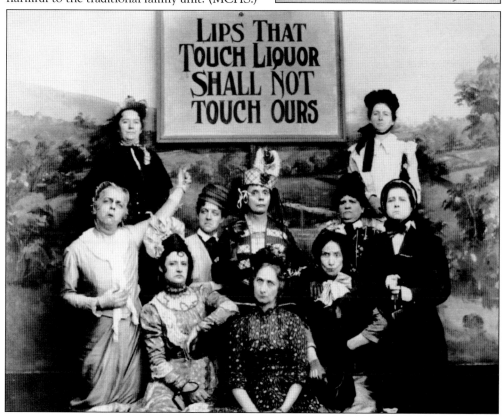

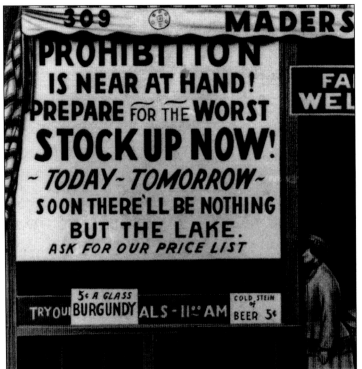

Mader's, originally known as "the Comfort," was a well-known German restaurant located at 1041 North Old World Third Street. It has been a prominent fixture in Milwaukee since 1902. When Prohibition threatened the dining experience of his guests, Charles Mader retaliated by posting this sign. Good advice, considering Prohibition only forbade the production and sale of alcohol—not its consumption.

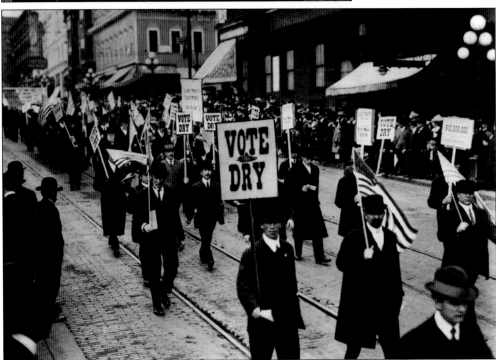

Since men were the target of the ASL and the temperance union, it was only fitting that men should campaign in favor of Prohibition. These well-dressed men, orderly and tidy, are declaring their support of responsible men, whose obligation is toward family and home. (MCHS.)

Pabst-ett, produced during Prohibition, was a canned cheese spread. Advertised as "tasty and easily digested," it was packaged in easy-to-use cans. In 1927, Kraft Foods sued Pabst, arguing that the brewery had infringed on a Kraft patent for its processed cheese, Velveeta. Kraft won the case, and the two companies entered into a licensing agreement; Pabst would continue to produce the cheese in Wisconsin, but it would be sold through Kraft. (MCHS.)

Prohibition brought out the creative side of many people. Just as with any law, someone always finds a loophole. The Volstead Act permitted certain uses of alcohol, such as paint products, religious services, and some medicinal use. This prescription form, signed by a physician, allowed patients access to alcohol—for medicinal purposes, of course. (MCHS.)

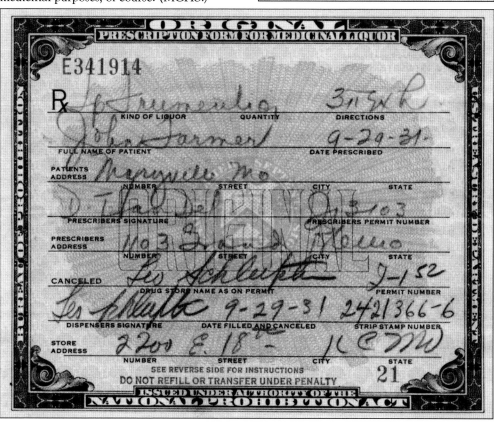

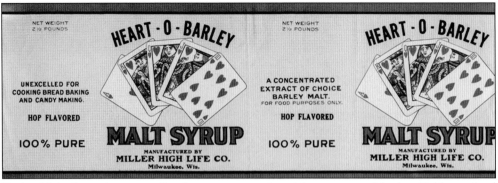

Barley Malt Syrup is an unrefined sweetener produced from sprouted barley. Sold as a food supplement for children and invalids, malt syrup was produced during Prohibition to keep breweries afloat. It is also an ingredient necessary for brewing beer. With the right equipment, a good recipe, and nerves of steel, homemade beer could be produced. (MCMA.)

Although Prohibition outlawed the manufacturing of alcohol, consumers found inventive ways to make their own. This filtration system, intended to make juice, could be adapted to the beer making process. Used in conjunction with malt syrup, home brewers were able to satisfy their thirst. (MCHS.)

116

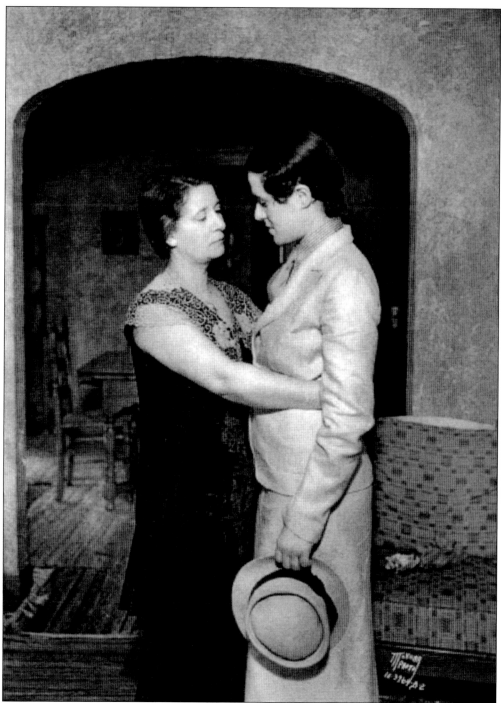

Few individuals opted to make their own brew, as most left that to the more industrious. Jennie Justo, pictured here on the right bidding her mother farewell, was known as the "Queen of Bootleggers." A student at the University of Wisconsin, Madison, Justo set up a campus speakeasy for classmates. Her studies were interrupted when she was arrested and spent a year in prison. Bootlegging became a booming business, making back room brewers rich. (WHS.)

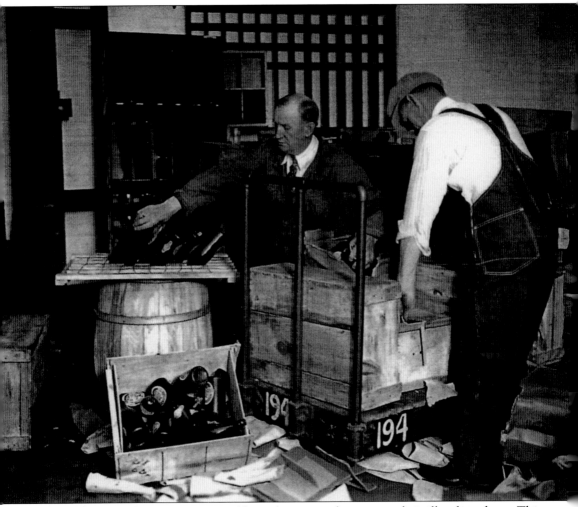

Bootleggers used every means possible to disguise and transport their illegal products. This confiscated load was seized from a bootlegger's speedboat, the *Amberhurst*, during a run on Lake Michigan. Counting bottles are Deputy US Marshal Bill Phillips (left) and an unknown assistant. (MCHS.)

The lucrative business of bootlegging outweighed the dangers of home brewing. This home in South Milwaukee was leveled by an explosion during the brewing process. One of the chief causes of exploding home-brewed bottles is inadequately fermenting beer before bottling. Even disasters such as this did little to discourage illegal activities; the perpetrator just moved on to another location. (MCHS.)

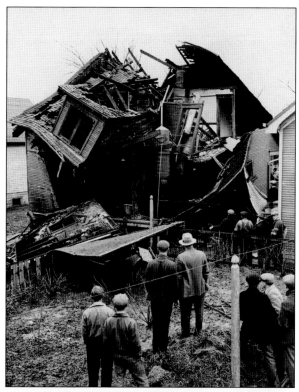

Federal agents work to open a boarded entryway at Harry's Tire Shop. For every successful raid, many other operations went undetected. Poor training, corrupt agents, and the simple danger of such raids made the life of an agent short. The violence and lawlessness associated with bootlegging became one small aspect in the campaign to repeal Prohibition. (MCHS.)

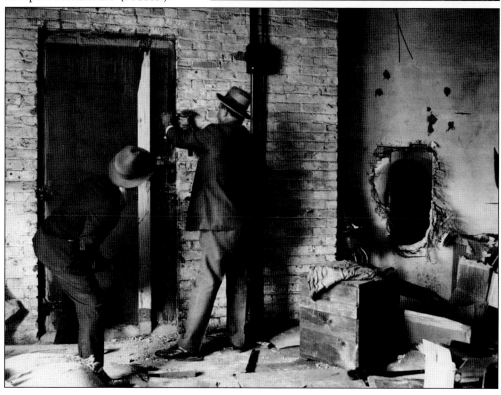

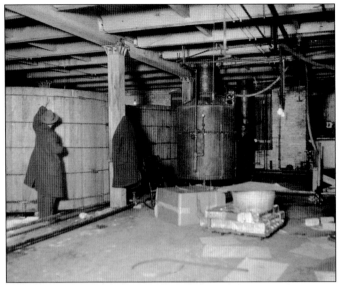

A federal agent conducting the raid on Harry's Tire Shop stands near a vat of alcohol and a boiler. This operation was extensive, considering the size of the vats, and brought in millions of dollars of untaxed income. Prior to personal income tax, the government generated revenue through alcohol taxes. No alcohol meant no taxes. The lack of revenue, coupled with the lawlessness and corruption, gave cause to consider the repeal of Prohibition. (MCHS.)

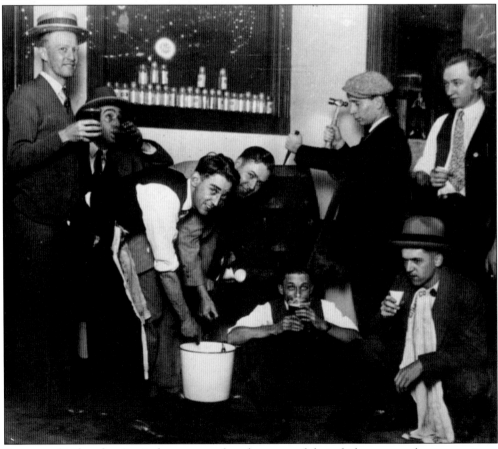

A group of *Milwaukee Sentinel* reporters take advantage of their darkroom speakeasy to enjoy a beer break. Pictured from left to right are Red Thisted, Eddie Oroth, Guy Helsm, Otto Brinkman, Ira Bickhart, Alvin Steinkopf, Benny Benfer, and Mr. Carr. (WHS, MJS.)

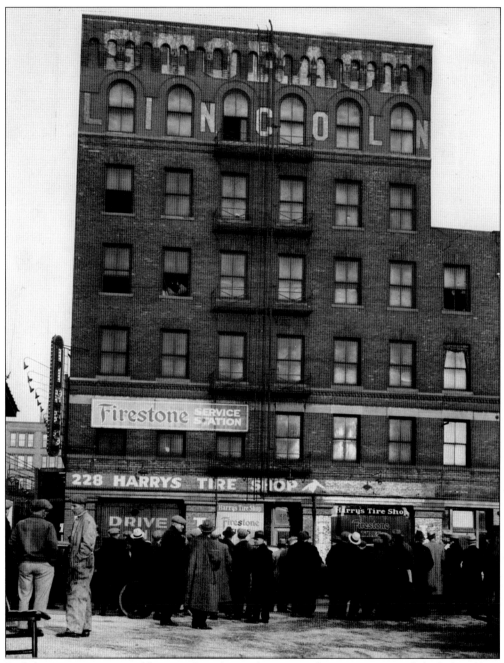

Prohibition was a national ban on the sale, production, and transportation of alcohol in place from 1920 to 1933. The Volstead Act implemented the 18th Amendment, and federal agents were hired to enforce the law. A crowd of bystanders gathers at the scene in front of Harry's Tire Shop during a raid in Milwaukee. Bootlegging ran rampant, and larger operations had a definite criminal atmosphere. An extremely profitable venture, bootlegging was well organized but dangerous. (MCHS.)

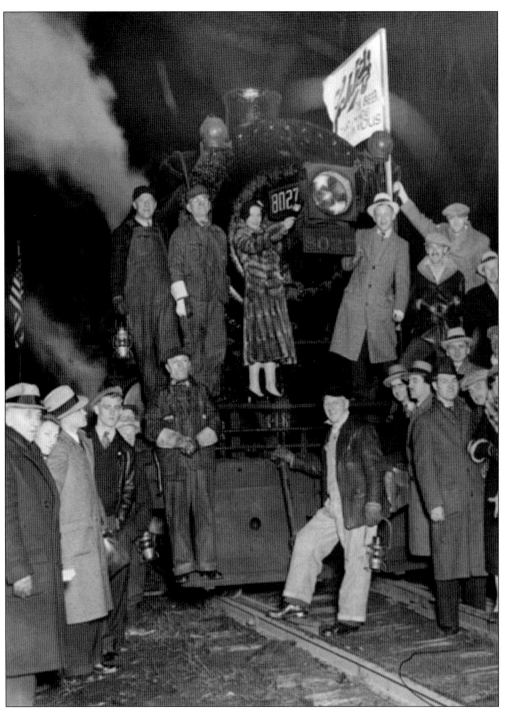

Schlitz engine No. 8027 blew its whistle as it departed the station at 12:01 a.m. on April 7, 1933, signaling the end of Prohibition and its readiness to resume national delivery. Loaded in anticipation of that moment and ready for departure, the train was met by a group of revelers. Standing on the train from left to right are R.D. Miller, Jesse Worner, A. Basta, Edward Wroblewski, Anton Plewa, and engineer William Kay. (MCHS.)

*Ten*

# BREWPUBS, MICROBREWERIES, AND HOME BREWERS

Milwaukee is brewing again, and it's not just the big guys anymore. A hankering for something different and something brewed on a smaller scale has prompted the explosion of microbreweries and brewpub startups in the city. Microbreweries are leading the revival of Milwaukee's downtown. Resembling their predecessors 160 years ago, this new breed of brewer is taking Milwaukee by storm and brewing in a new direction. Sure, they're brewing traditional ales and lagers, but they've added their own twist. New varieties like Horney Goat's Chocolate Cherry Stout, Rock Bottom's India Pale Ale, Water Street Brewery's Dopplebock, and Stonefly's Moustache Ride Pale Ale are urging customers to belly up to the bar in growing numbers.

Retirement, career change, and a desire to be one's own boss have prompted microbrewery entrepreneurs to establish their own brand of beer. Taking a nod from the past, new brewers serious about their craft follow the same traditional path to earn their brew master title. This includes entry into an established professional master brewer program followed by an apprenticeship.

The Brewers Association (BA) defines a craft brewery as small, independent, and traditional, producing less than six million barrels a year, and another alcoholic beverage company cannot own more than 24 percent of it. With the growing number of small production startups, the BA reports that, in 2012, there were 2,075 regional craft breweries, microbreweries, and brewpubs in the United States. The Milwaukee area boasts 14 brewpubs that serve at least four on-site-produced brews on tap (some contract off-site) as well as a limited food menu. Appealing to a younger clientele, brewpubs and microbreweries are creating a welcoming atmosphere that encourages brand loyalty. One of the first 50 brewpubs in America, the Water Street Brewery is Milwaukee's first and oldest brewpub, now celebrating 25 years of continued success.

On an even smaller scale, home brewing is on the rise. Availability of local ingredients, relatively low startup costs, and short production times has contributed to this growing hobby. To a home brewer, there is nothing better than impressing friends with your own creation.

Horny Goat Brewing Co. and Jim Sorenson's Horny Goat Hideaway, located on Milwaukee's south side, opened in 2009. Housed in a repurposed 1929 pump house, this brewpub has become a major destination, attracting a large clientele. The urban, industrial architectural elements of Horny Goat complement the neighborhood's industrial feel. Brew master Dave Reese brews on site, offering eight beers on tap and seasonal offerings, including Sexy Saison and Watermelon Wheat. (APC.)

Milwaukee Ale House is located in the heart of the city and offers amazing views of the Milwaukee River. One of Milwaukee's best nightspots, it features its own house-brewed selection of ales and lager, including Hop Happy. The river patio and dock enhance the view, as does the urban feel of a revitalized commercial and residential area. (APC.)

Russ and Jim Klisch established the Lakefront Brewery in 1987 as a result of brotherly rivalry, trying to "outbrew" the other. Confident that they could produce a good product, they started small. Eventually, they outgrew their space and moved to a repurposed coal-fired power plant. Today, they produce 14 year-round beers, seven seasonal recipes, and organic and gluten-free varieties. The brewery has won over 200 awards in its 25 years of brewing. (APC.)

Rock Bottom Brewery, although a national chain, has a good following in Milwaukee. Overlooking the Milwaukee River, this microbrewery brews on site and encourages patrons to view the process through brewery windows. At all times, the brewery offers 12 beers on tap, including seasonal recipes such as Red Ale and Specialty Dark. (APC.)

Home brewing as a hobby is booming. Often starting with kits received as gifts or on a whim, home brewing opens a new facet of beer for an increasing number of beer lovers. Why home brew? Some say too many reasons, but mainly, enticing friends with new styles of brew is number one. Joe Loftus of Menomonee Falls, Wisconsin, whose home brew is called Joe's Irish Dogs Brewing Co., says it is his favorite way to relax after crunching numbers all day. (APC.)

Water Street Brewery, Milwaukee's first brewpub, opened in November 1987. The brewery features seven house beers and seasonal recipes on tap. Centrally located, this downtown pub is one of three in Wisconsin, but all brew their own beer, including Honey Lager Light, Amber, and Raspberry Weis. In the past 20 years, the brewery has won 16 medals at the Great American Beer Festival. (APC.)

Randal Sprecher established the Sprecher Brewery in 1985 in the Menomonee Valley area of Milwaukee. Already knowledgeable as a brewing supervisor at Pabst, Sprecher decided to try brewing on a smaller scale. From the beginning, he held one standard: brew the finest European and traditional beers and gourmet sodas available anywhere. His varieties include Hefe Weiss and Black Bavarian. Soda line products include Orange Dream and, of course, root beer. (APC.)

Love for one's favorite glass of brew has launched various types of beer-centered businesses, but this has to be the cleverest. This novel idea—described as a mobile tavern, beer bike, beer trolley, or trolley pub—is catching on. Piloted by one designated driver, and powered by many, these roving bars are extremely popular. Even if its patrons aren't drinking light beer, they will burn the calories they're taking in. (APC.)

# DISCOVER THOUSANDS OF LOCAL HISTORY BOOKS
## FEATURING MILLIONS OF VINTAGE IMAGES

Arcadia Publishing, the leading local history publisher in the United States, is committed to making history accessible and meaningful through publishing books that celebrate and preserve the heritage of America's people and places.

## Find more books like this at
## www.arcadiapublishing.com

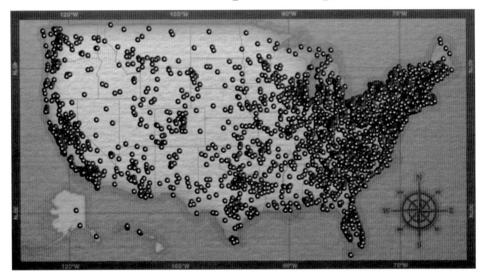

Search for your hometown history, your old stomping grounds, and even your favorite sports team.

Consistent with our mission to preserve history on a local level, this book was printed in South Carolina on American-made paper and manufactured entirely in the United States. Products carrying the accredited Forest Stewardship Council (FSC) label are printed on 100 percent FSC-certified paper.

MADE IN THE USA